IMAGES
of America

PRICE HILL

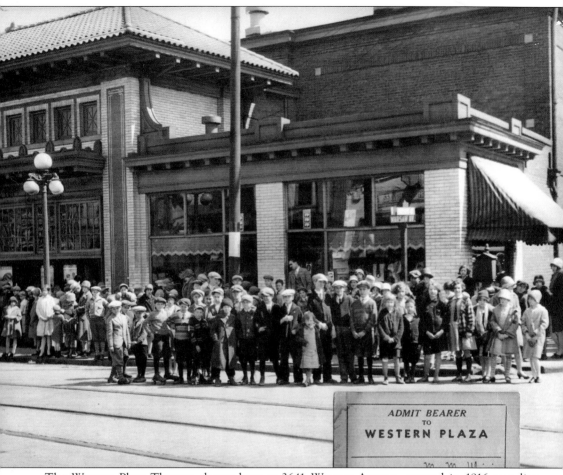

The Western Plaza Theatre, shown here at 3641 Warsaw Avenue, opened in 1916 as a live theater. This picture shows Price Hill children who have gathered to attend a free premiere of *Robin Hood*, a 1924 silent movie starring Douglas Fairbanks Sr. The theater was razed in 1965. The photograph was donated to the Price Hill Historical Society by Dot and Susie Nicholson in 1996. Their younger brother, Louis, at age 11, is in the group. (Price Hill Historical Society.)

On the cover: Please see above. (Price Hill Historical Society.)

IMAGES
of America

PRICE HILL

Christine Mersch
with the Price Hill Historical Society

ARCADIA
PUBLISHING

Published by Arcadia Publishing
Charleston, South Carolina

Printed in the United States of America

Library of Congress Catalog Card Number: 2008925864

For all general information contact Arcadia Publishing at:
Telephone 843-853-2070
Fax 843-853-0044
E-mail sales@arcadiapublishing.com
For customer service and orders:
Toll-Free 1-888-313-2665

Visit us on the Internet at www.arcadiapublishing.com

*This book is dedicated to all those who have lived in Price Hill,
whether it be for just a few months or all their lives.*

CONTENTS

ACKNOWLEDGMENTS

Sincere thanks go to the Price Hill Historical Society for all its help in researching this book, especially Richard Jones, who was the impetus for this project, and Julie Hotchkiss, who was an excellent fact-checker and editor. All photographs or documents are used with permission from the Price Hill Historical Society unless otherwise noted.

Thanks also go to those who donated their pictures and their time, including Ruth Austing, Amy Banister, Sam Beltsos, Jack Doll, Aimee Hart, Marian Hartmann, Saul Marmer, and Larry Schmolt. Also, I would like to thank my editor at Arcadia Publishing, Melissa Basilone, plus my husband, Mark, and my family for supporting me during this project.

INTRODUCTION

People have lived in Price Hill for hundreds of years—there once was a Native American mound near where Rapid Run Road and Overlook Avenue intersect today, one of several mounds in western Cincinnati that were probably built by Woodland culture Native Americans at least 1,000 years ago. The first European settlers arrived in the late 18th century, when there were still members of the Miami and Shawnee tribes living in the vicinity. William Terry and his family are generally acknowledged as the first white residents of the hill. Terry bought 200 acres of land from John Cleves Symmes, built a cabin, and established a farm and orchard.

Cincinnatians began to move up to the hilltop high above the city's basin for cleaner air quality and more land on which to build. In the 1830s, the Warsaw settlement was established near where Carson Elementary School is in 2008. It quickly grew into a self-sufficient community, with a school, smithy, and tavern. In the middle of the century, the Neff family began to build several mansions on the eastern crest of the hill, and a Welsh immigrant named Evan Price invested in land west of the Mill Creek. His son, Rees Price, established a brickyard and sawmill in the area, catering to the housing boom on the hill. The area was soon known as Price's Hill.

Rees had two sons, John and William, who also helped establish Price Hill by building an inclined plane in 1874 for passengers. In 1876, the freight side of the incline opened. The incline and a bridge built over the Mill Creek in 1870 made it much easier for people to travel between the city and Price Hill. The eastern part of Price Hill, formerly Storrs Township, was officially annexed by the City of Cincinnati in 1870.

Churches and schools were established early; the Fischer Schoolhouse in the village of Warsaw was operating by 1828. As the student population grew, it was replaced with the Warsaw School and then Carson Elementary School. In 2008, Carson Elementary will have a brand-new building for the 21st century.

St. Lawrence Church was the first Catholic church established on the hill, in 1870, but it was soon followed by many others. Protestant churches, such as Westminster Presbyterian, which the Neff family helped to found, were established, as well as two synagogues. St. Lawrence had a school, as did the convent of the Sisters of Charity at Mount St. Vincent, which is now Seton High School. Elder High School and Western Hills High School were both opened in the 1920s.

As a thriving community, businesses began to spring up along Warsaw Pike, the neighborhood's first business district. Grocers and dry goods stores stood beside taverns and building and loan associations (some of the building and loan associations actually met in the back room of taverns when they were first established). The first park in Price Hill was Mount Echo Park, still

a beautiful green space in the community. The community's first library was a Carnegie library, built on land donated by Price Hill resident Edward J. Dempsey, a judge and former mayor of Cincinnati.

Residents were active in local and city politics from the earliest days of the community, and they formed civic associations to keep their neighborhood strong—and to make sure their voices were heard in city hall. The Price Hill Civic Club was established in 1915, and the East Price Hill Improvement Association arose out of an attempt to keep the incline open in the 1940s. Both organizations are still helping the neighborhood today.

Judge Dempsey was one of more than a half dozen mayors who have ties to Price Hill. The first was Elisha Hotchkiss, the second mayor of Cincinnati. Hotchkiss's son was an early settler on the hill, and his descendants built many of the homes and public buildings in the community. Then there was Robert M. Moore, an Irish immigrant who served in the Mexican War and led a company of local soldiers as a colonel in the Union army during the Civil War. His beautiful Italianate home still dominates the view from the city toward Price Hill.

Later in the 20th century, Edward N. Waldvogel sat in the mayor's office. Renowned for his flashy style of dressing, one could still find him cutting the grass in his yard on Ridgeview Avenue if one wanted to talk. The Sixth Street viaduct is officially named the Waldvogel Viaduct after him. Next was Donald D. Clancy, an Elder High School graduate who was mayor in the late 1950s and later became a U.S. congressman. Eugene P. Ruehlmann, a Western Hills High School graduate who lived on Cleves Warsaw Pike, was mayor during the 1960s, and Gerald R. Springer, a resident of Western Hills Avenue, was one of Cincinnati's youngest mayors in the 1970s—"Jerry" went on to further fame hosting a talk show.

Other names in Price Hill's history are reflected in the names of streets, such as Considine and Bassett and Murdock. Famous Price Hill residents include Catherine Mary Brophy, one of the first female professional golfers, and Doris Day. The infamous George Remus helped provide the eastern half of the United States with the alcoholic beverages it craved, although they were inconveniently outlawed during Prohibition. Remus was Price Hill's own Gatsby, living in a beautiful mansion on West Eighth Street that had been built by a beer baron named Henry Lackman. Although he may not have been a pillar of society, Remus certainly put Price Hill on the map for a while, as did another native son, Pete Rose. Rose started his baseball career at Western Hills High School and broke baseball records, won multiple World Series games, and, like Remus, eventually spent a little time in jail.

Price Hill is like that: a great neighborhood with some unpolished edges and a lot of great characters, many of whom could be found in any number of drinking establishments in the neighborhood. The 52 Bar on Glenway Avenue is allegedly so named because it was the 52nd bar located on that street as one came up the hill from town. Maybe you can remember other saloons and taverns that have operated here, such as Moeller's Grill, Dittelberger's, the Ideal Café, the Crowe's Nest, Streibig's, Brauer's Café, Peggy's Grill, and the Golden Fleece. And if that last one does not ring a bell, it is the bar attached to Price Hill Chili. Everyone knows where that is! Still, the honor of the first chili parlor in Price Hill goes to Skyline Chili, which operated its flagship restaurant on Glenway Avenue from the mid-1940s until 2002. Skyline founder Nicholas Lambrinides said he named his chili parlor for the view out the kitchen window, across the Mill Creek Valley to the skyline of Cincinnati beyond.

That brings us back to where we started, on that high ridge west of the city that has been an appealing place to live for centuries. There is a lot of history here, and much of it has been captured in the photographs in this collection. Take a moment to step back into our neighborhood's past—and enjoy your trip through Price Hill's history.

—Julie Hotchkiss, Price Hill Historical Society

One

SCHOOLS AND
SPIRITUALITY

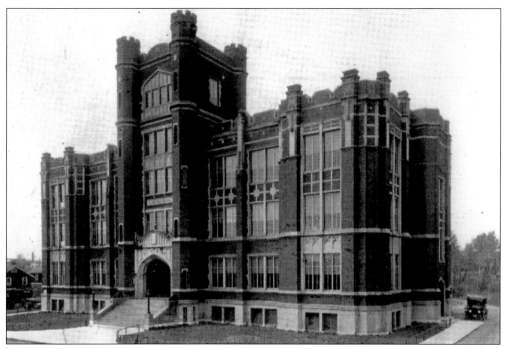

Elder High School began as a school within St. Lawrence School. But by the 1920s, it was clear another school was needed. The cornerstone for Elder was laid in 1922 at Vincent and Regina Avenues. The building was completed in 1923, and the first class of eight students graduated that same year. The school was named in honor of the third archbishop of Cincinnati, William Henry Elder, who served the archdiocese from 1880 to 1904.

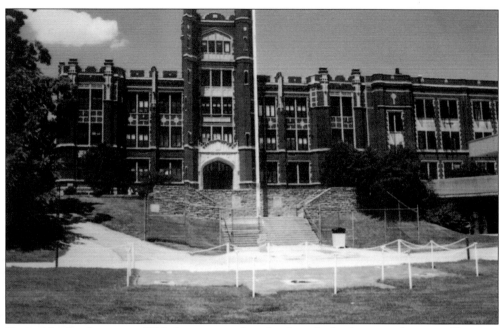

During the first five years of Elder's existence, the school taught both men and women. However, when Seton High School opened as a parochial school for girls in 1928, Elder became an all-boys school staffed by the priests of the archdiocese and lay teachers. From the time the school opened its doors until 2008, 20,000 students have graduated from Elder High School.

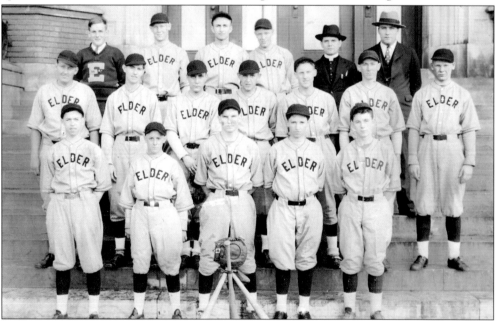

Students at Elder High School have always excelled in sports. This picture shows the 1929 baseball team, one of the best in the city that year. Elder's football team has also received its share of awards. The school built a premier high school football stadium, which, thanks to a strong school spirit, was completed by December 1947 with the help of students, alumni, and relatives.

By 1957, when this picture was taken, Seton High School had long been established in the Price Hill community. Seton High School got its start as Mount St. Vincent Academy in 1854, when it opened in the Sisters of Charity convent named Cedar Grove. This all-girls school was first a sister school to Mount Alverno, an all-boys academy in neighboring Delhi; both schools were run by the Sisters of Charity of Cincinnati. The convent building had been built in the 1840s by the Alderson family that lived there for many years before selling the home to the Charity nuns. Harrison Alderson was a judge, and at that time, the house was called the Cedars. This is probably because there was an avenue of cedar trees leading to it. The house was on Plank Road, which later became Glenway Avenue.

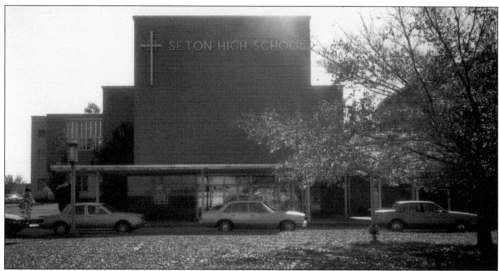

In the 1920s, Archbishop John T. McNicholas encouraged the merging of smaller schools into larger parochial high schools that would be split based on gender. On September 12, 1927, the Sisters of Charity changed the school to reflect McNicholas's suggestions and changed the academy's name to Seton High School, an all-girls parochial high school named for the patron and founder of the Sisters of Charity, Elizabeth Ann Seton.

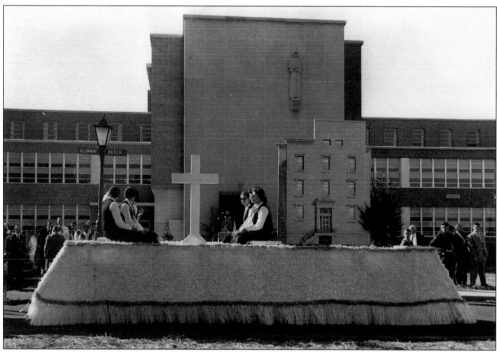

On October 20, 1957, Seton High School students and faculty celebrate their 30th anniversary. In 1963, the freshman building—a one-story structure named St. Elizabeth Seton Hall—was built on Vincent Avenue to accommodate more students. The 1967–1968 school year saw the highest enrollment in Seton with 1,554 students. Enrollment later decreased, and by 1980, St. Elizabeth Seton Hall closed. In 2008, Seton High School is still educating young women.

Western Hills High School was planned on 29 acres of land on Ferguson Road previously named the Hartupee Tract. On March 19, 1926, building started on the 22-room school, and on September 10, 1928, classes opened with 1,500 students and 65 teachers. The land cost $43,860, and construction cost $1.145 million.

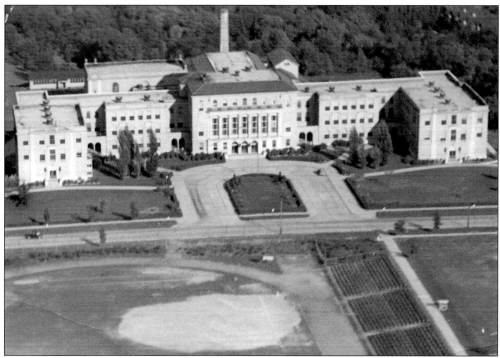

The Western Hills High School building was designed by Garber and Woodward in a classical style, mostly brick trimmed in stone. On January 6, 1932, two murals painted by Francis Wiley Faig were dedicated and presented to the school. In 2008, the murals still hang in the school's entranceway. Two additional wings were added in 1938 to accommodate 3,000 students.

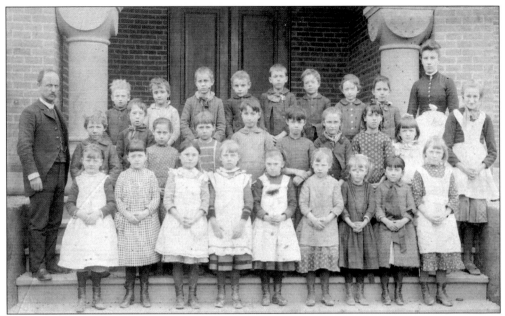

Children attending the Carson Elementary School at 4323 Glenway Avenue include Pete Scherder, Tim Carberry, Earl Sunderman, H. Meyer, Chris Bettinger, Louise Liegel, Kate Binder, Manuel Hay, Emma Schafer, Rose Fingerhut, Lizzie Vokadis, Grace Wright, Ella Huemmel, ? Linderman, Lillie Beakman, Mamie Phohl, Stella Ritter, ? Graingers, and Bertha Wildey. Principal John Carson stands on the far left. In 1916, this building was torn down and a new school was built in its place.

Carson Elementary School was originally called Warsaw School, and the school's first principal was John Carson. Carson Elementary was named after its beloved principal, who continued to work as principal. In 2008, a new school building is being constructed near the original school building location. Administrators say the building will open for the 2008–2009 school year.

Members of Whittier School celebrate during their fall festival in 1900. This picture was taken on Considine Avenue. The Whittier schoolhouse is one of the first known schoolhouses in Price Hill. This school was first named the Mansion Place School in 1891–1893 because classes were originally held in the Boyle mansion.

The Boyle mansion was torn down to build this schoolhouse, pictured here on Osage and Woodlawn Avenues. On September 8, 1894, the school opened its doors again as the Whittier Public School. In the fall of that year, due to overcrowding, schoolchildren and employees moved into three temporary frame school buildings on the Boyle property. The building shown here burned to the ground on June 14, 1958. A new Whittier school building was built at 945 Hawthorne Avenue and was demolished in 2008.

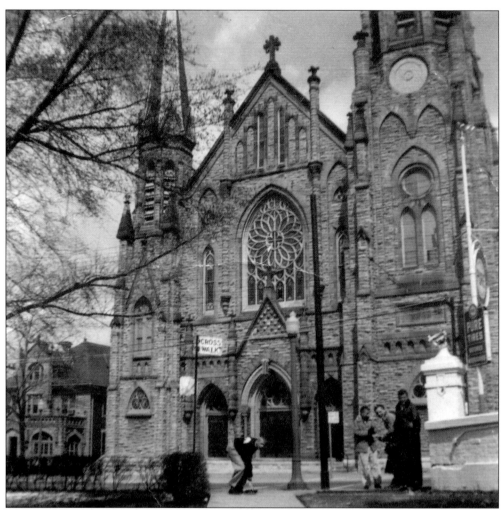

The St. Lawrence Church was the first Catholic church built in Price Hill. Fr. John Bonner bought an acre of land between Warsaw Avenue and Rapid Run Road on July 13, 1868, and on June 12, 1870, a small church was dedicated after St. Lawrence the Martyr. Church services were held on the second floor, and the school, which opened in September of that year, was downstairs. On May 27, 1885, Archbishop William Henry Elder bought the Blaesi home on St. Lawrence Avenue to use as a schoolhouse. Plans to build a new church building were drawn up in 1883, and a roofed basement structure was finalized by May 22, 1887, at its present-day location on Warsaw Avenue. The current school originally opened in 1905. By 1912, the Brothers of Mary started teaching seventh and eighth grades at the school, a division called the Elder High School after the late archbishop William Henry Elder. By 1920, the St. Lawrence school had grown significantly, and it still operates in 2008.

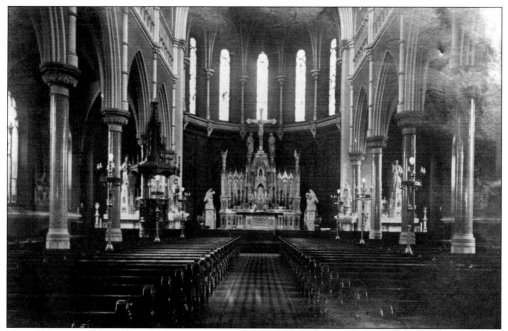

The interior of St. Lawrence Church is truly stunning. By 1893, the parish had the money to build a grand upper church on top of the existing one. Designed in a 14th-century style, this new church was 160 feet long by 72 feet wide and featured two stunning front towers, the highest of which is 189.5 feet.

St. Lawrence Church members gather together for their annual festival sometime in the 1960s. Forty years prior, St. Lawrence Church was consecrated, meaning that the church's structure was architecturally significant, the parish was permanent, and all debts were paid. In 1949, the church was again remodeled, and in 1983, a new gymnasium and parish hall were built. Due to its long-standing history, this church boasts the nickname Mother Church of Price Hill.

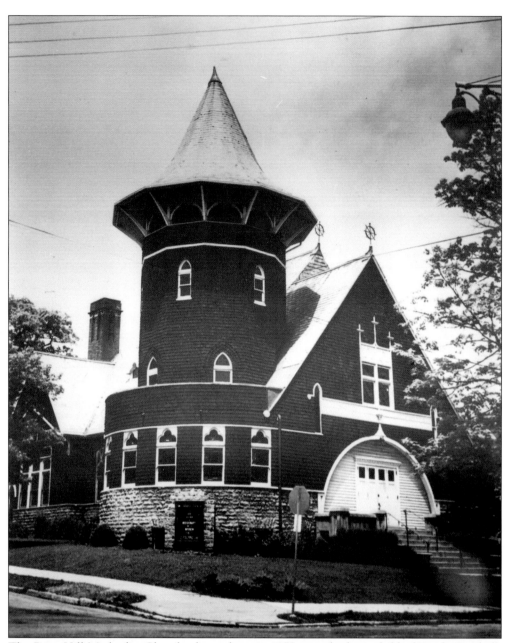

The Price Hill Methodist Church, shown here in 1958, was the brainchild of Zerah Getchell. He called other residents together on September 9, 1884, to discuss building a new Methodist church. They named their parish the Methodist Episcopal Church, and construction began on a new house of worship immediately. Until then, services were temporarily held at Library Hall and the Westminster Presbyterian Church, both of which were at Price and Grand Avenues, and an old school building on Park Avenue. The parish's Ladies' Aid Society was formed about this time, and the group helped raise money for the church's construction. Church attendance and funds struggled through the 1930s, but the congregation was once again going strong in 1940. It is interesting to note that during World War II, a Red Cross knitting unit was formed, and women of the church knit warm sweaters, socks, and caps for American troops.

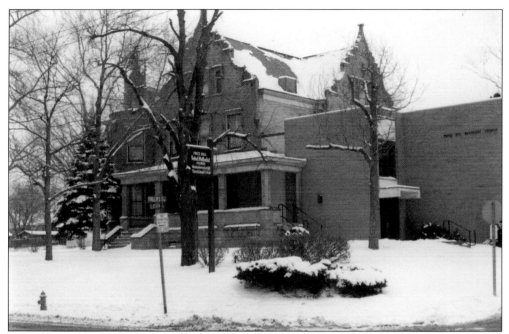

By 1959, the Price Hill Methodist Church had again expanded and bought the John L. Barth house, originally built around 1900 on Phillips and Elberon Avenues. The church used the mansion for extracurricular activities, such as Sunday school and social rooms, until it was torn down in the early 1960s. It built an educational/sanctuary unit next to the mansion in 1966.

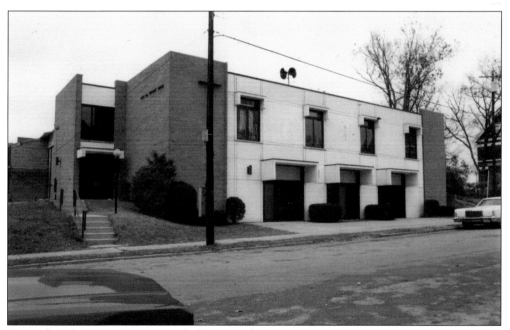

Groundbreaking ceremonies were held on Sunday, August 13, 1978, and Don Spaulding had the honor of breaking ground. The cornerstone was laid in 1979. In the mid-1960s, the parish sold the educational building (on Phillips and Considine Avenues) to the Church of the Nazarene. As of 208, this church still owns the building on page 18.

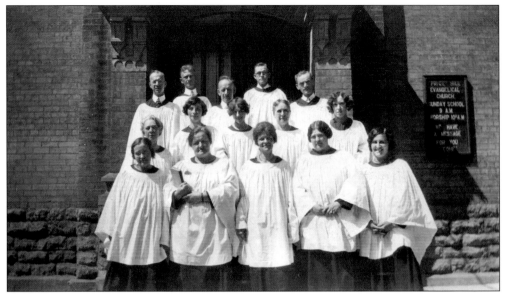

The Price Hill Evangelical Church choir stands outside the church (pictured below), around the early half of the 1900s. The parish held its first service on October 4, 1885, in Sister Sturm's Warsaw Avenue home. By June 13, 1918, Die Erste Evangelische Protestantosche Kirche had changed its name to the more American-sounding Price Hill Evangelical Church; by 1927, it had 375 members.

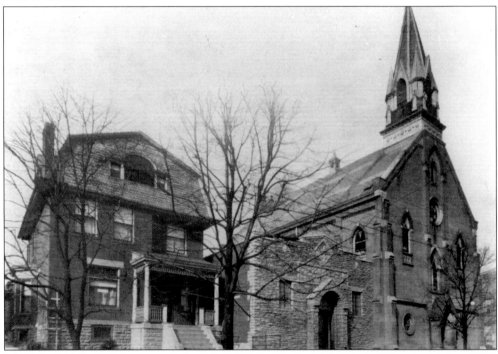

Members laid the cornerstone of the Price Hill Evangelical Church building in August 1886, and the first service was held on November 18, 1888. In 2008, this building still stands on 931 McPherson Avenue, but the majority of the parish has since joined with the St. Peter and St. Paul United Church of Christ congregation, located at Queen City and Ferguson.

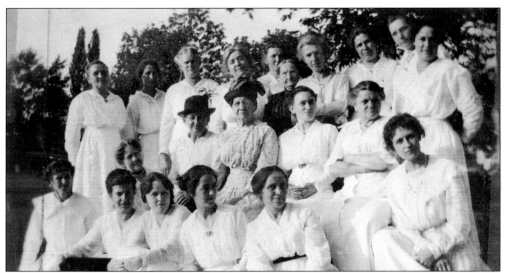

The Ladies' Aid Society of the Price Hill Evangelical Church, shown here, met at Wilson Park on June 24, 1917. By 1925, the parish was growing at a rapid rate and needed to expand, yet had no money. A kindly parishioner, who wished to remain anonymous, gave $10,000 to the expansion project, and parishioners raised the rest of the money. The new building was dedicated on February 27, 1927. The church was later called the Price Hill United Church of Christ Evangelical and Reformed Church.

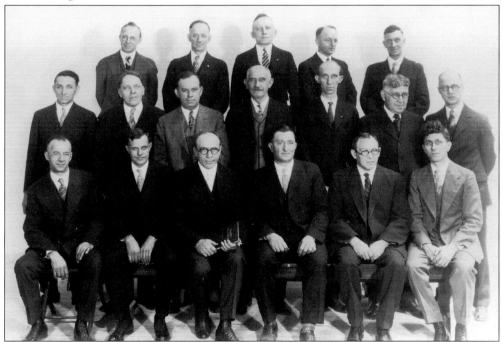

In the 1940s, the Evangelical church council included, from left to right, (first row) F. W. Betz, F. G. Vordenberg, Rev. W. E. Uhrland, F. E. Seitz, Frank Kripner, and William J. Seitz; (second row) Charles Drott, ? Fox, Fred Wildey, Eberhardt Budke, Al Webler, H. C. Koerber, and John F. Ruehlmann; (third row) F. W. Dietrich, Joseph Betz, Walter Schenkel, Louis Fisher, and Chris Seitz.

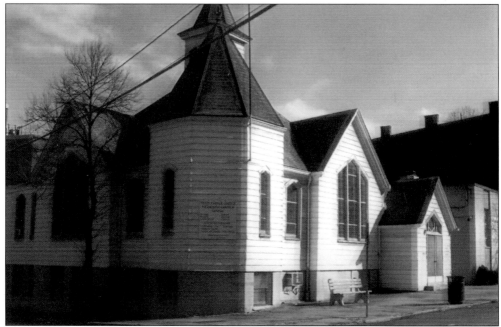

This church was built at 686 State Avenue, on the corner of Storrs Street, in 1930 and was originally the Methodist Episcopalian Church. On December 22, 1944, the board of trustees of the State Avenue Methodist Church bought the building for use as a meeting place, and in 1964, the property was transferred solely to the State Avenue Methodist Church. In 2008, the church still stands.

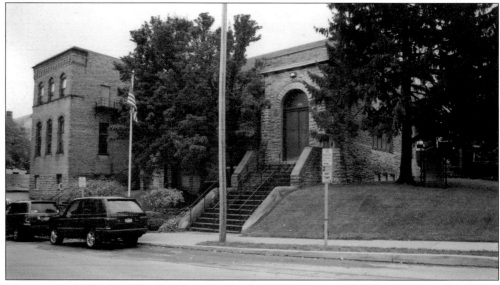

The Episcopal Church of the Nativity, organized in 1875 by Rev. J. Mill Kendrick, may have been the first Protestant congregation in Price Hill. In 1880, a chapel was built on Grand Avenue and West Eighth Street. The church moved to this building on Hawthorne and Phillips Avenues eight years later. A newer church building was constructed in 1892 at 682 Hawthorne Avenue. In 1998, it merged with St. James Episcopal Church on Montana Avenue in Westwood. In 2008, this building still stands.

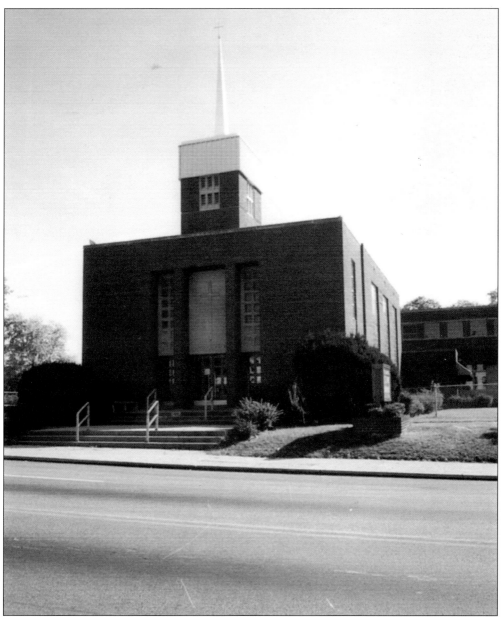

In 2008, the Heritage Community Church holds services at this building on 4431 Glenway Avenue. The Price Hill Baptist Church started on November 9, 1899, when Lottie and Edward Schwarz and Pearl and Ida Story gathered at 938 Enright Avenue, the home of Henry Schwarz. Lottie, along with the help of Etta Lauber, taught religion classes to children in Henry's home. This fledgling parish soon grew too big for the house, and space was donated by the Plymouth Congregational Church at Glenway and Warsaw Avenues. As the congregation grew, more space was purchased at 3777 Warsaw Avenue on June 6, 1901. Before the new building was completed on June 7, 1903, Sunday school and worship services were held in an old store/saloon on Warsaw Avenue near Sturm Street. After World War II, the church moved again to this current location. The new church building was dedicated in February 1952, and an additional educational wing was added in 1958.

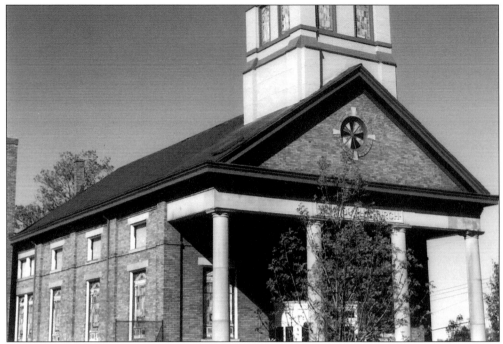

The Plymouth Congregational Church was founded in 1886 and stood at Glenway and Quebec Avenues. In 1912, a new, larger church was built on the same location: 3800 Glenway Avenue. On July 1, 2004, the church combined with the Price Hill Baptist Church and formed the Heritage Community Church; its services are held at 4431 Glenway Avenue. The Plymouth building at Glenway and Quebec Avenues closed in December 2003, although it still stands in 2008.

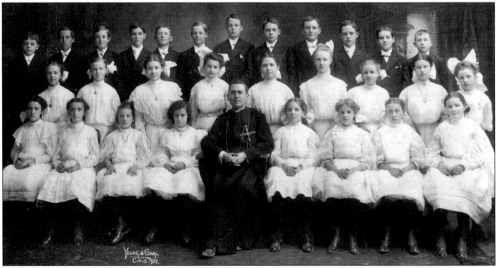

Members of Holy Family Church celebrate communion in 1907. A meeting on May 20, 1883, in the parlor of Mount St. Mary's Seminary at Grand and Warsaw Avenues decided the fate of Holy Family Roman Catholic Church. Rev. John Menke was chosen as the first pastor, and on August 24, 1884, the church opened for services. Classes were held at Mount St. Mary's Seminary until construction on a school building was completed.

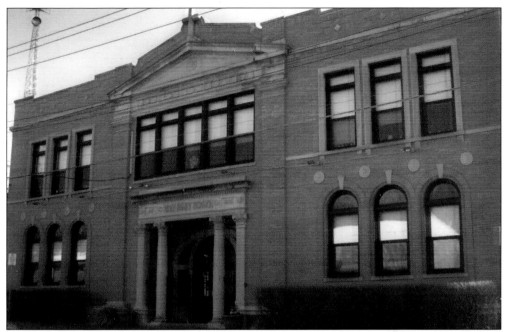

In June 1916, Holy Family parish held dedication services for a new church at West Eighth Street and Hawthorne Avenue. This picture shows the Holy Family School, which is at 3001 Price Avenue. In 2008, more than 160 students from kindergarten to the eighth grade attended. Also, many Sisters of Charity members remain as teachers.

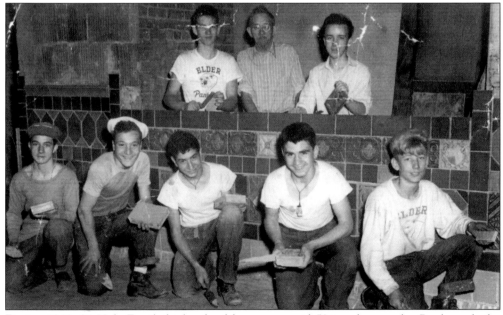

During 1948, 24 Holy Family high school boys were paid 50¢ an hour to lay Rookwood tiles in the school's cafeteria. From left to right are (first row) Jim Lang, Sammy Mirizzi, Angelo Caminiti, John Sparto, and Tommy Hoe; (second row) Rich Hoe, Joseph Neyer (the contractor), and Tom Dugan. Neyer purchased a load of "reject" tiles from famed Rookwood Pottery (in Mount Adams) for $75. On February 14, 1949, the cafeteria formally opened.

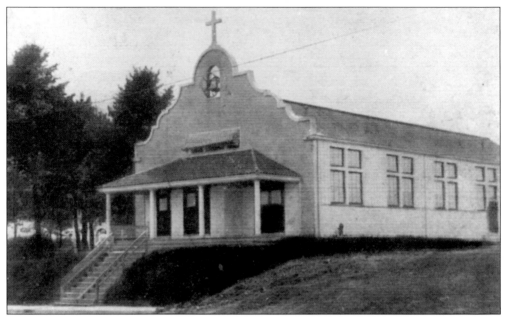

Construction began on this St. William Church on March 18, 1910; the first service was held in May of that year. Built on land donated by Herman Elsaesser on the corner of Reed (now St. William Avenue) and Rosemont Avenues, the parish was named in honor of St. William the Abbot and the late archbishop William Henry Elder. In April 1911, a new school building opened, and in 1915, a new addition was built to relieve crowding.

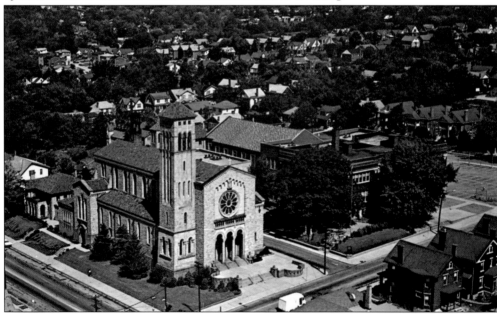

In 1918, the St. William Carnival was held to raise money for a new, larger church building. This carnival is credited with being one of the first such parish festivals, a tradition that continues in 2008. St. William Avenue was blocked off to make room for a large tent showing boxing and wrestling matches. By March 14, 1929, they were ready to build this grand new church on the corner of West Eighth Street and Sunset Avenue.

This postcard shows students from St. William's in the eighth grade in 1939; Peggy McKimmie is in the second row. One year after this picture was taken, St. Michael Church in Lower Price Hill had to remove its steeple for structural reasons, and St. William Church bought the bells. In 2008, Price Hill residents can still hear these bells calling people to mass, weddings, and other events.

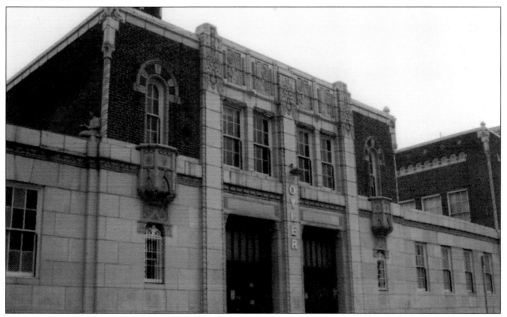

The Oyler school was built on Hatmaker Street in Lower Price Hill and is still an active school in 2008. Designed by Samuel Hannaford and Sons, this school was originally the Storrs Township or 21st District School. In 1901, it was renamed the George W. Oyler Public School after its retiring principal. Two playgrounds were built on the rooftop of its building, due to the high cost of land at the time.

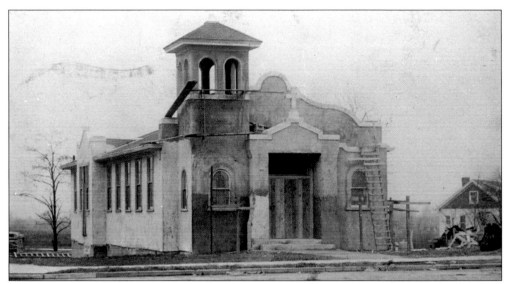

On August 3, 1916, Fr. Joseph B. Mueller met with 40 families to found St. Teresa of Avila Church, named after a 16th-century Carmelite nun. On September 10, 1916, the group held its first mass at Mueller's house at 1070 Overlook Avenue. A proper church was built in just 21 days at the corner of Overlook and Glenway Avenues, thanks to help from 200 parishioners. Designed by Anthony Kunz, this church was blessed on Christmas Eve 1916.

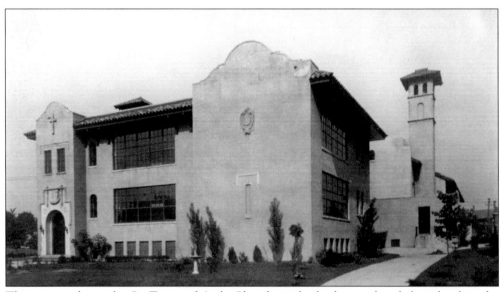

This picture shows the St. Teresa of Avila Church in the background and the school in the foreground, in 1930. In 1918, the first St. Teresa of Avila school opened with 70 students and two Sisters of Mercy teaching; Sr. Mary Veronica, also the school's principal, taught the upper grades, and Sr. Mary Aneselm taught the lower grades. This eight-room schoolhouse was built in 1922, and newer school buildings were built in 1940 and 1956.

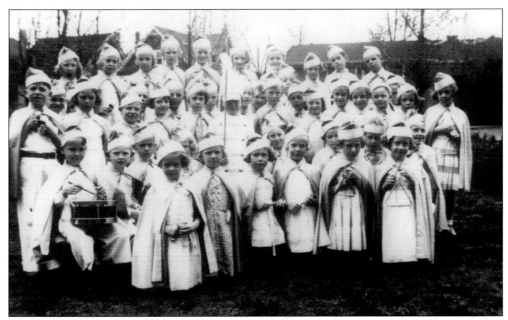

The St. Teresa's Second Grade Band, shown here, was formed in 1936. Fr. Joseph B. Mueller, a pastor in the early 1900s, would often visit the children at school and was known to dismiss classes because "It's too pretty a day to be inside." In 2008, the St. Teresa of Avila School still stands on 1194 Rulison Avenue, and the St. Teresa of Avila Catholic parish continues to operate at 1175 Overlook Avenue.

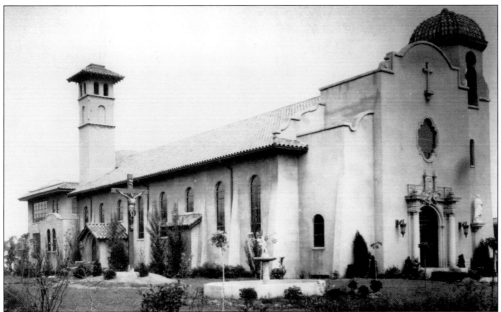

The church pictured was built in 1922. In 1954, the church celebrated its new church bells, bought from the distinguished St. Peter in Chains Cathedral downtown. These bells were made in 1851. Parishioners broke ground for a new church in February 1960, and construction finished in time to hold Christmas Eve mass in 1962. The church shown here still stands in 2008 and is used for Boy Scout meetings and after-school day care.

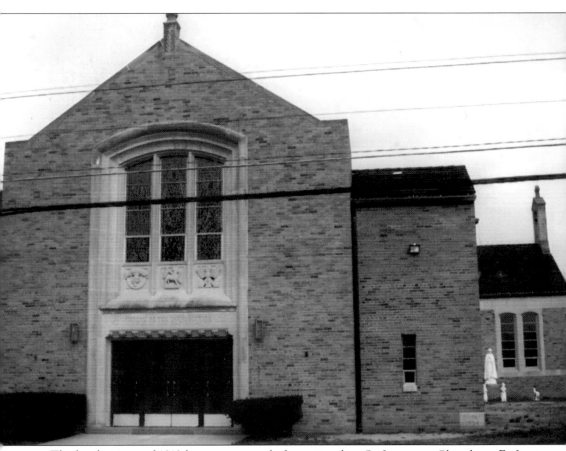

The harsh winter of 1919 kept many people from attending St. Lawrence Church, so Fr. Louis Nau, a priest at that church, proposed that a new church be built. On April 24, 1919, plans were discussed and the proposal made to name the church St. Louis Church of Price Hill, after Nau. Out of modesty, Nau declined and suggested the Church of the Resurrection of Our Lord. It was built on Iliff Avenue, and Rev. Joseph Sund, the pastor of Our Lady of Victory Church in Delhi, helped celebrate the laying of the cornerstone on August 3, 1919. By December 7, 1919, the first mass was celebrated in the new building. By 1952, attendance had grown such that a new church was needed, and the parish purchased land on First Avenue. In 1954, ground was broken for the new structure, and by July 26 of the next year the project was finished. In 1964, men from the parish chipped in to complete additional repairs and renovations. In 2008, both the church and the school are still in operation.

Resurrection School opened for classes on Monday, March 8, 1920, with 150 children. Three years later, attendance had grown to 263 students, and in 1924, new classrooms were built. A pastor house was built in 1926, and in 1927, a house was purchased on Iliff Avenue for the sisters who taught at the school. By 1936, the parish boasted 645 families with 450 students in school.

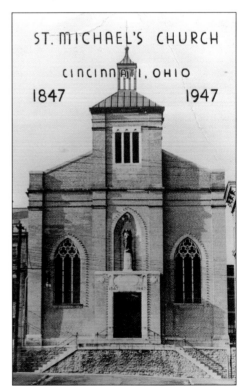

This St. Michael Church postcard invites locals to St. Michael's centenary celebration on Sunday, September 28, 1947. After the church and school opened originally, a second school was built in 1856. Then, in 1905, the present-day school building was built. Although the parish is no longer open in 2008, the church still stands and the school is used as a community center, offering social services and GED classes.

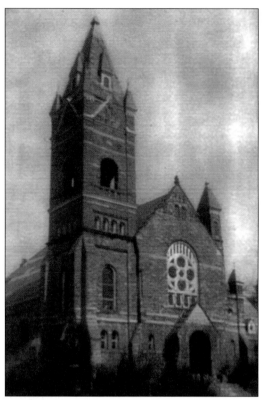

The Westminster Presbyterian Church was organized on October 1, 1883, at Peter R. Neff's home at 2700 Glenway Avenue. The pictured church at Price and Grand Avenues was built in 1887 and merged with Overlook Presbyterian Church in 1941. It moved to Overlook Avenue and then to Cleves Warsaw Pike before merging with St. John's United Church of Christ around 2000. In 2008, the congregation is St. John's Westminster Union Church on Neeb Road in Delhi.

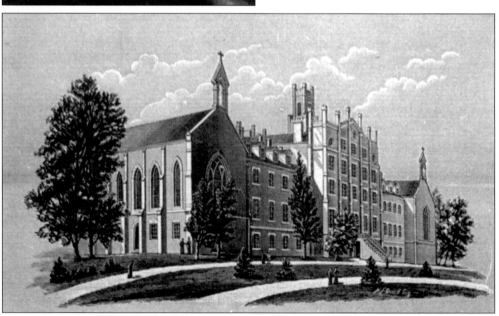

This lithograph is of the Mount St. Mary's building that stood at Warsaw and Grand Avenues from 1851 to 1904, thanks to land donated from Patrick and Michael Considine. Mount St. Mary's Seminary was a Roman Catholic school that first taught aspiring priests, and then collegiate and preparatory classes were added in the early 1850s. Orphaned and delinquent girls were taught in the building from 1905 until 1959. The Price Hill property was razed in 1962.

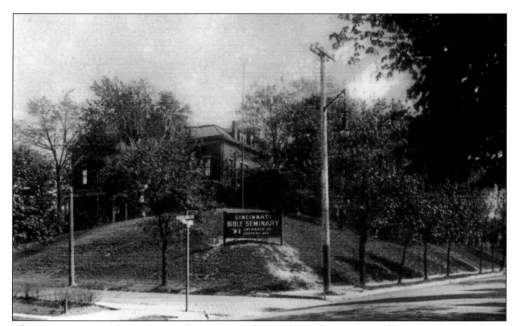

The Cincinnati Bible Seminary first organized in 1923 and was originally located in the West End on West Eighth Street. In 1924, it merged with a similar school, the McGarvey Bible College, and held classes here at Grand and Maryland Avenues. In 1939, the school bought the old Grandview Sanitarium at 2700 Glenway Avenue. In 2008, it is still located there and is now called the Cincinnati Christian University.

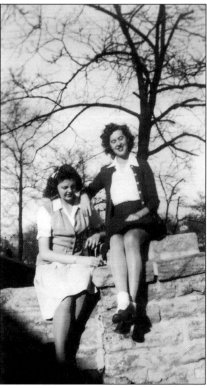

Carolyn Osterhaut (left) and Betty Curd Geiger sit on the wall leading to Foster's Garden in 1943. At the corner of Chateau and Maryland Avenues, this garden belonged to the Cincinnati Bible Seminary. In the 1950s, the school built a women's dormitory on the campus and stopped using the surrounding houses. As a result, the houses—which were part of the old campus—were sold and eventually razed for newer apartment buildings.

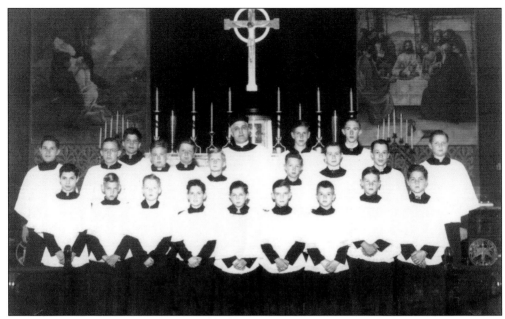

Altar boys at the church of Our Lady of Grace pose for this picture in 1946. In 1929, the parish was started to accommodate overflow of Holy Family parishioners. Both a church and school were built at 1216 Considine Avenue and served Price Hill residents for 60 years. In 1989, Our Lady of Grace merged with the Holy Family parish. Around 2002, the school building was used as the Whittier School Annex.

Our Lady of Grace celebrated its golden jubilee—50 years of existence—in 1979. Just 10 years later, the parish celebrated its final mass on August 13, 1989. Fr. Jim Meade was the last pastor. The building was torn down in 2004. In 2008, the Rees E. Price Academy, a Cincinnati public school, operates on the same area.

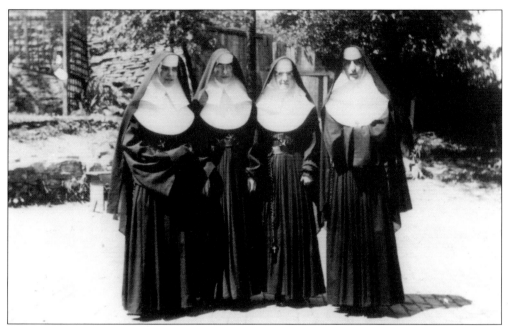

The Sisters of Mercy of Blessed Sacrament parish pose for a picture. This Catholic church stood at Wilder and Glenway Avenues. The building was dedicated on May 8, 1892. The parish raised enough money to start building a school in 1904. By October of the next year, the school opened to students. In 2008, neither the church nor the school stands.

The Sephardim Beth Shalom Spanish Hebrew Synagogue, shown here, served Jews who mostly immigrated from Spain and the Mediterranean area. The Beth Jacob Synagogue on St. Lawrence Avenue served Jews from eastern European countries, such as Russia, Hungary, and Romania. Founded in 1919, members of the Beth Jacob Synagogue met in the basement of a structure on St. Lawrence Avenue. By 1925, they built a larger brick building, and a Hebrew school opened in 1935.

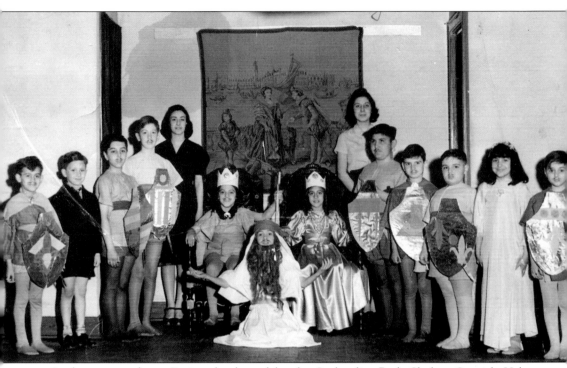

Students pose after a Purim play hosted by the Sephardim Beth Shalom Spanish Hebrew Synagogue. The synagogue stood at 1262 Manss Avenue; this picture was taken in 1939. From left to right stand Jim Levy, Jack Benmayor, Sam Trabout, Carl Sedacca, Lena Yosafat (director), Lee Benmayor (director), Issy Menache, Bobby Ackrich, Jack Hazen, Dorothy Menache, and Maurice Trabout. Evelyn Levy is dressed as Queen Esther, and King Ahajuerus is Dave Casutu. Joe Yosefat is dressed as Mordecai. This synagogue was dedicated on March 19, 1934. Cincinnati, in particular, was very receptive to Jewish immigrants, and many moved to Price Hill for its better air quality. Attendance declined at the Sephardim Beth Shalom Spanish Hebrew Synagogue in the 1980s, and it closed in 1987. In 2008, the building is now the Solid Rock Church of God. By the 1970s, the Beth Jacob congregation had also declined, and in 1978, it sold the building to the Church of God, a Christian community from Lower Price Hill.

Two

CAREERS

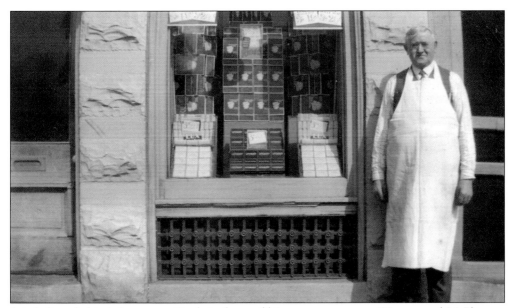

It is believed this is Lawrence Cook in front of his grocery store on Warsaw and McPherson Avenues. Lawrence and his wife, Alma, had a son, Bud Cook, on July 21, 1918. The family lived at 917 McPherson Avenue. Bud served in the army during World War II and then returned to work as a butcher in his father's market. In 1962, Lawrence sold the store and Bud opened his own meat market on Cedar Avenue in College Hill.

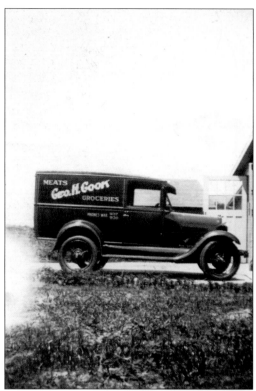

Bud Cook probably drove this truck a lot while working at his father's grocery store. From 1968 to 1980, Bud switched gears and careers, supervising school transportation for both the Northwest School District (Green and Colerain Townships) and the school district in Berea, Ohio. He retired to Delhi, where he and his wife, Harriet, enjoy their 5 children, 10 grandchildren, and 3 great-grandchildren.

On June 4, 1875, George Meyers proposed that a water tank be built on his property, and in October 1880, tank construction was complete. The tank was almost filled to capacity on June 29, 1881, when it broke, gushing 2.248 million gallons of water. By 1894, four new water towers, shown here, were built but became too costly to maintain. The area was turned into Glenway Park, which still stands between Considine and Purcell Avenues.

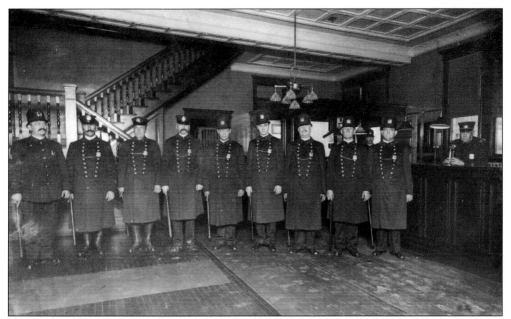

Officers stand inside the Warsaw Avenue Price Hill police station around 1907. The first Price Hill police station was built in 1902 on State Avenue, near West Eighth Street and was originally called District 9. A new station was built at the top of the hill at 3201 Warsaw Avenue in 1907. During consolidation efforts in 1927, District 3, which was originally at 73 East McMicken Avenue, combined with District 9, and the new station was renamed District 3.

This Price Hill police station building at 3201 Warsaw Avenue is still used as an active police station in 2008. In 2008, Capt. Kimberly Frey is the District 3 commander, and there are more than 150 officers on staff. This police station covers 14 area communities, including East, West, and Lower Price Hill.

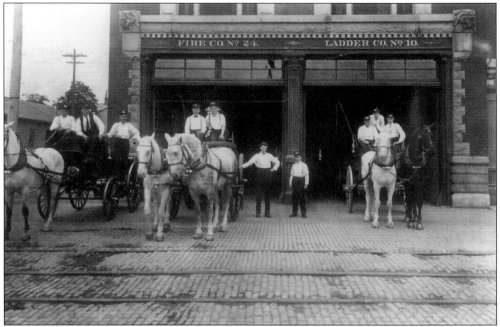

This Price Hill fire station was originally built on Warsaw and Considine Avenues in 1889. It was home to Fire Company No. 24 and the Ladder Company No. 10. In 1894, the fire department nicknamed its fire engine the "Lewis Wisby." This massive engine could dispense 500 gallons of water per minute through 1,800 feet of two-and-a-half-inch cotton hose.

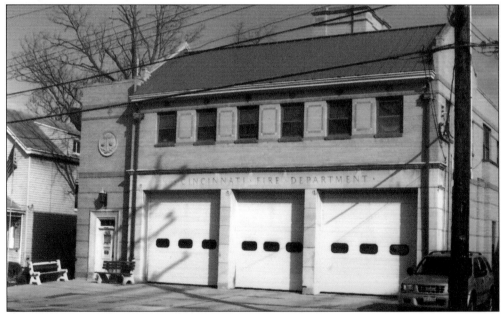

Due to the community's expansion, a new firehouse opened at 4526 Glenway Avenue in 1940; prior to this, the Motz Blacksmith Shop stood on land adjacent to this. In 2008, this location is home to the current Price Hill fire station, Engine Company 24, and Rescue 24, a paramedic unit. The old firehouse building, pictured above on Warsaw Avenue, still stands, although it is no longer used as a firehouse.

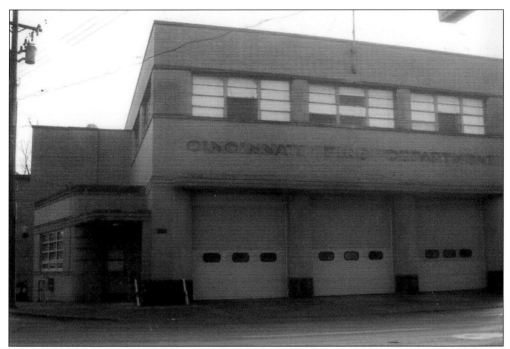

This Cincinnati Fire Department Engine Building No. 17 still operates in 2008. An early fire department in Lower Price Hill was first built at 608 Neave Street (on the corner of English Street) in 1871 and suffered one fatality; on November 30, 1929, Albert Klingler died while responding to a fire alarm. This building, now on 2101 West Eighth Street, was built in 1953.

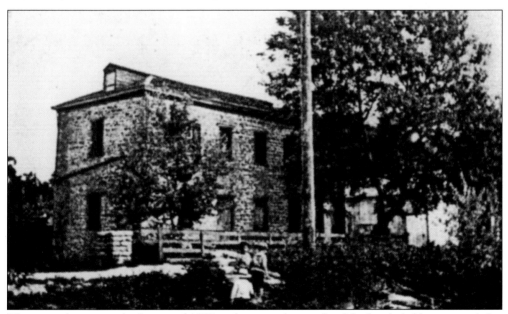

This stone house was built around 1850 and was used as a school for local children around this time. The building still stands at Queen City and Sunset Avenues. During the Civil War, the City of Cincinnati used this building as a jail annex to hold an overflow of prisoners from the downtown jail.

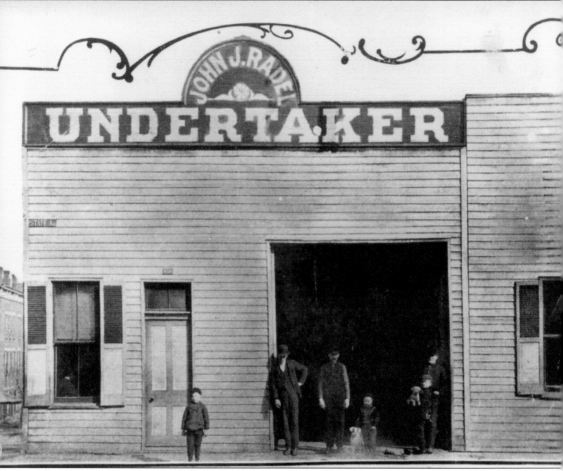

John J. Radel started in the funeral service business in 1878 in this building at 652 State Avenue, right on the corner of St. Michael Street. He offered a wide range of funeral services, including offering an early life insurance plan. In 1912, John replaced his horse-drawn carriages with automobiles, receiving national attention as one of the first funeral companies to do so. He also opened a bus service from downtown Fountain Square to Price Hill—a five-mile trip that cost just 5¢. This business foray soon ended. In 1917, John J. Radel died, leaving his son, Henry J., in charge. Henry expanded the company, opening a business at 822 York Street in Newport, Kentucky, in 1927; at 4122 Glenway Avenue in Price Hill in 1933 (a house originally built in 1891 as the home for H. Joseph Schulte and his wife, Mary Magdalene Wenning Schulte); at 1005 Madison Avenue in Covington, Kentucky, in 1938; at 1804 Vine Street in Cincinnati in 1950; and at 2562 North Bend Road in Cincinnati in 1962.

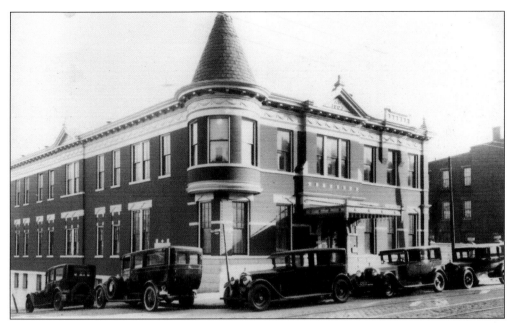

On January 1, 1903, John J. Radel incorporated the business and named it the John J. Radel Company. Also during this year he built this new funeral home building on the same State Avenue location. Henry J. Radel died in August 1973, and his two sons, Henry Jr. and Fares, took over the company. They opened three more funeral homes—one at 6943 Montgomery Road, one at 650 Neeb Road, and one in Highland Heights, Kentucky.

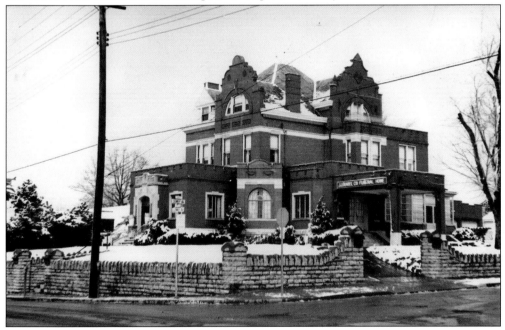

In 2008, the Radel Funeral Home stills stands at 4122 Glenway Avenue. The Radel funeral business was split into two divisions in 1993. The homes in Newport and Highland Heights are operated by Fares J. Radel Funeral Homes, Inc., and the Radel Funeral Service Company owns both the 4122 Glenway Avenue (in Price Hill) and 650 Neeb Road (in Delhi) locations.

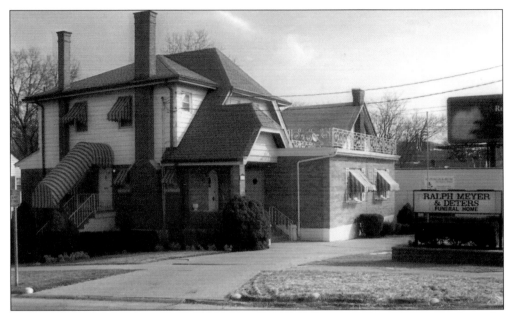

The Ralph Meyer and Deters Funeral Home building was built in 1926 and was a residence for many years. In 1955, the Meyer family bought it for use as a funeral home, with Ralph and his son Glen in charge. By 1985, the Bolton and Lunsford funeral home took over this building, keeping the Meyers name. In 1990, Terri Deters bought it, continuing the funeral home.

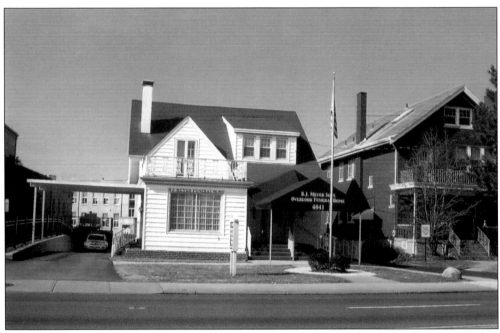

Ben Meyer started the B. J. Meyer Sons Funeral Homes in 1884. The first Meyer's funeral home was at 3747 Warsaw Avenue, but in 1923, it purchased a bigger house across the street at 3726 Warsaw Avenue. In 1950, Vince and Gene Meyer purchased this house at 4841 Glenway Avenue. In 2008, Gregory A. Meyer runs this home and the B. J. Meyer Sons Funeral Home at 5864 Bridgetown Road.

Price Hill's original post office was established in 1891. Residents originally received mail from Post Office Station F in Lower Price Hill. With population growth on top of Price Hill, a new post office building, shown here, opened in 1913 at 3749 Warsaw Avenue. In 1963, a new post office building was built at 975 Enright Avenue and is still in operation in 2008.

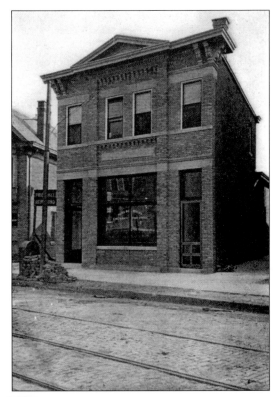

Seen here is 4434 Glenway Avenue, home of Ed Horning piano tuning and restoration. He also buys and sells pianos and has been in business many years. Ed and his wife, Deborah, were founding members of the Price Hill Historical Society, and the society held its meetings in a hall above Ed's piano shop for several years.

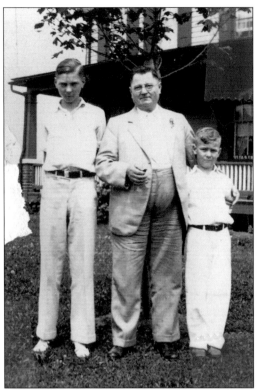

Conrad Hartmann stands in the center of this picture with his two sons, Bob (left) and Bill. Conrad started the Hartmann Bakery in 1901 at Liberty and Moore Streets in downtown Cincinnati. As the city expanded, he moved west to Western and Freeman Avenues in 1932. He retired, and his son Bill took over. Bill moved the Hartmann Bakery to 4937 Glenway Avenue, where the store stayed for just two years.

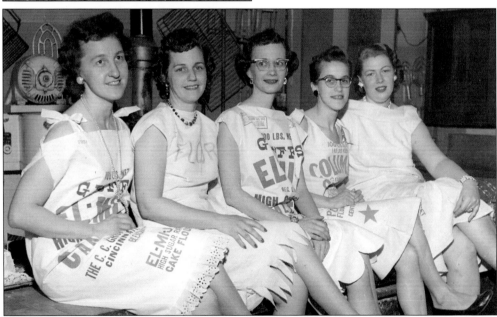

In 1949, this group of women made dresses out of flour sacks. They are, from left to right, Mary Ann Acree, Marian Hartmann, Kathy Girmamn, Maxine Jennings, and Ruth Strassbuger. All were involved in the bakery business. Marian Hartmann co-owned St. Lawrence Bakery with her husband, Bill, for 57 years. In 2008, Mary Ann Acree is the current secretary of the Greater Cincinnati Retail Bakers Association.

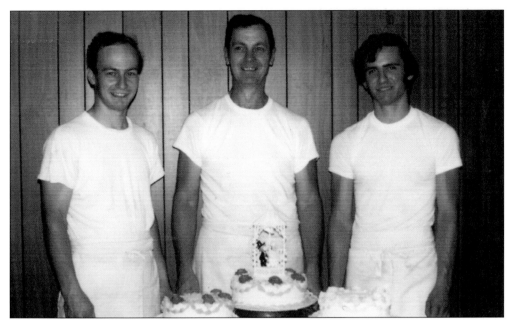

In 1951, the Hartmann Bakery moved to St. Lawrence Corner at 3715 St. Lawrence Avenue. Bill renamed the Hartmann Bakery the St. Lawrence Bakery because at the time every store on that corner had *St. Lawrence* in its name. Bill's two sons, Bill Jr. (left) and Paul (right), worked as bakers and ran the store upon Bill's retirement in 1981. In 2008, the two boys still work, making old-fashioned baked goods from original recipes perfected in 1901.

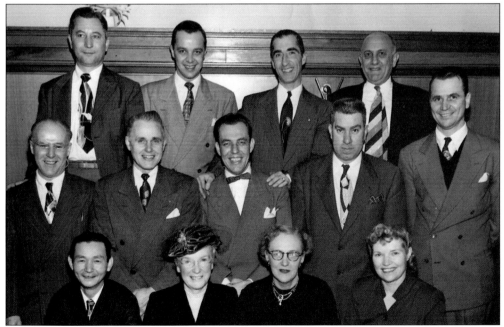

This picture shows a group of merchants who owned businesses on St. Lawrence and Warsaw Avenues. From left to right are (first row) Charlie Yee and three unidentified women; (second row) Ralph Quinn, Charlie Yeager, two unidentified, and John Herman "Ham" Luebbe; (third row) John Kuzma, unidentified, Fred Huber Jr., and another unidentified man.

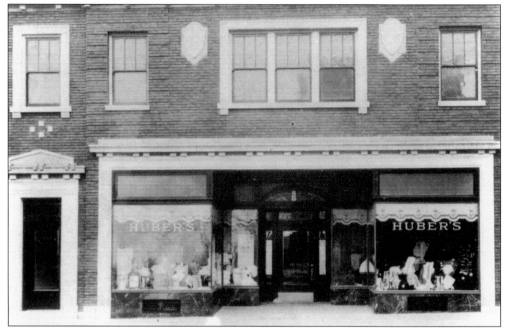

In 1908, Estelle Huber's dry goods store opened at 3529 Warsaw Avenue. The Huber family lived in the back room of the shop. Estelle mainly worked at the shop, selling high-end clothes and accessories, and her husband Fred's day job was as a metal spinner, although at night he helped out with the store. They were so successful that in 1929 they built a larger store (pictured here) at 3611 Warsaw Avenue.

Fred Huber Jr. (center) and Fred Huber Sr. (left) are pictured with an unidentified neighbor. Fred Jr. graduated from Elder High School and then joined the family business. In 1929, he expanded the store to 3611 Warsaw Avenue. He married Veronica Keller on September 11 of that same year, and the couple had four girls (Elaine, Marilyn, Janet, and Barbara) and one boy (Don).

Estelle Huber stands with her son Fred Huber Jr. Estelle also had two girls, Delores and Rosemary. Estelle's grandson Don married Carol Cunningham, and the couple had two boys and two girls. While Don worked at the family store, Carol worked as a school nurse. In 1992, Carol and Don were honored by being named grand marshals of the Price Hill Thanksgiving Day parade.

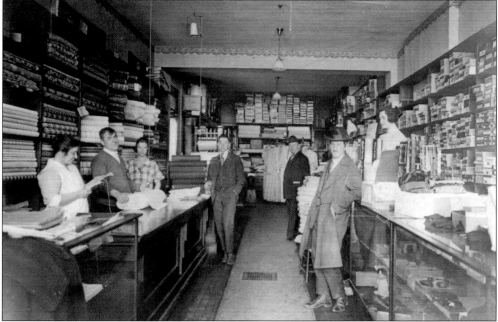

This picture shows the store in 1929 at 3611 Warsaw Avenue. The Hubers were in business for almost 90 years, as the store passed down through the generations from Estelle and Fred Sr. to Fred Jr. and finally to Don Huber. Don sold the store in 1997, and the building was razed in 2007 to make way for a new Kroger grocery store.

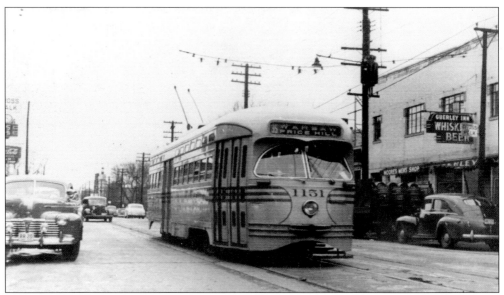

In the late 1950s, this streetcar is about to pass by Prout's Corner at Guerley Avenue and Cleves Warsaw Pike. In 1961, Sam Beltsos purchased property behind this streetcar and opened the Price Hill Chili restaurant with his father-in-law, Lazaros Nourtsis, who went by the nickname Pops. The restaurant opened in 1962 with 12 stools for seating by the counter and four tables.

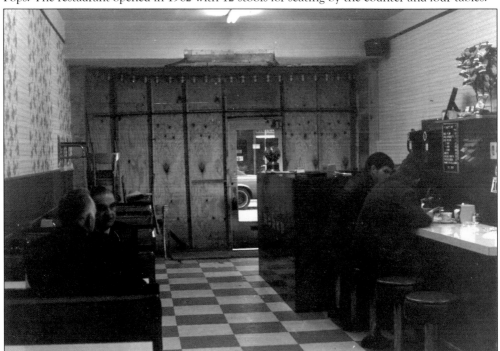

Price Hill Chili quickly grew in popularity due to its delicious, homemade Greek food, including gyros, double-decker sandwiches, and meaty chili. Beltsos remodeled the front of the restaurant (shown in this picture, taken from the back of the restaurant) and continually expanded over the years. He later opened an adjacent bar named Golden Fleece Lounge after the Greek myth of Jason and the Argonauts.

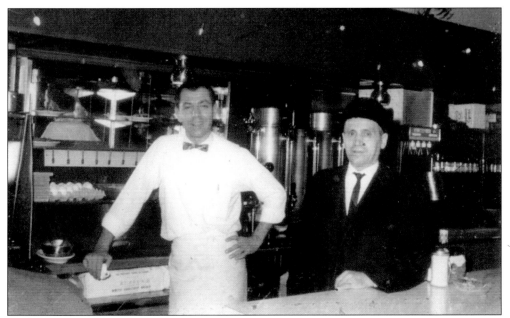

Both Sam Beltsos (left) and Lazaros Nourtsis (right) could often be found at the restaurant, as well as Beltsos's wife, Mimi. The family-style food and homey feeling of the restaurant quickly made Price Hill Chili popular among locals, turning the restaurant into a Price Hill landmark that has served six generations of residents. The restaurant has come to be so popular that Vice Pres. Dick Cheney stopped here in 2004 while campaigning.

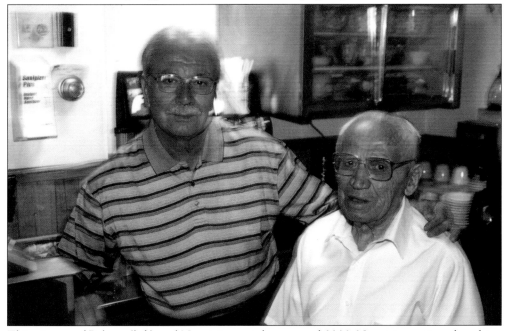

This picture of Beltsos (left) and Nourtsis was taken around 2000. Nourtsis continued working at the restaurant up until just a few weeks before his death in 2003 at the age of 95. Beltsos still works there, as well as his three sons, Steve, Paul, and Chris. In 2008, Price Hill Chili and the Golden Fleece Lounge still stand at 4920 Glenway Avenue.

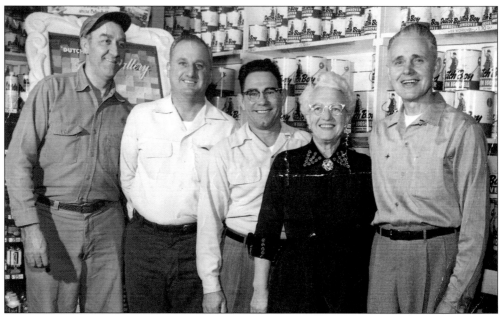

Employees at the Price Hill Paint and Glass Company stand for a picture taken for the *Dutch Boy* golden anniversary issue magazine. From left to right are Fred Reidinger, Elmer Minning, Bill Lienert, Mildred "Sis" Yeager, and Charlie Yeager. This picture was taken in 1956. Charlie Yeager opened this store in August 1921 in the former Hoffwessel Pool Room. He was in business for 61 years.

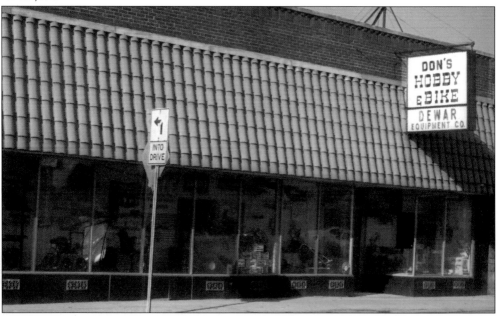

Don's Hobby and Bike Shop opened in May 1948 and in 2008 is still open. Owner Donald Dewar was born in April 1918, graduated from Elder High School in 1936, and was drafted in 1941. He returned home and bought a defunct candy store at Wells Street and Warsaw Avenue, renaming it Don's Sweet Shop. This later became Don's Hobby Shop and moved locations twice before settling in this old Woolworth's storefront at 4915 Glenway Avenue in 1963.

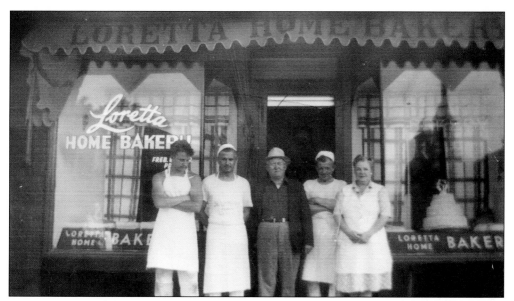

Loretta Home Bakery stood at 3100 Price Avenue and Hawthorne Street. This picture was taken in June 1946. From left to right stand Fred Engler (son), Fritz Engler (owner), Frank Seibert (grandfather), and Bernie, the store clerk. It is believed that Loretta herself stands on the far right.

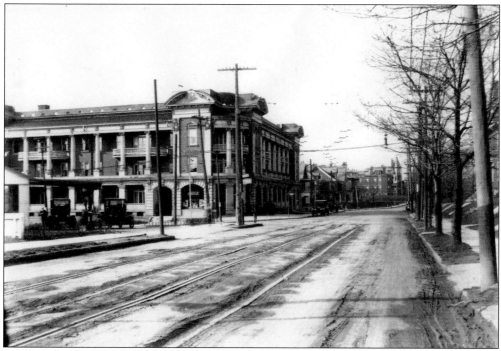

In 1907, the Lammert family owned a pharmacy in this Elberon apartment building at Elberon and West Eighth Streets. In the 1950s, Milton Lammert sold the pharmacy business to Norval Horton, who owned it until he sold it in 1981 to Don Moore. Moore operated Moore's Pharmacy here until 1986, when he bought Greg Haurtlaub's pharmacy at 4486 West Eighth Street. Don Moore's pharmacy is still open at 4486 West Eighth Street in 2008.

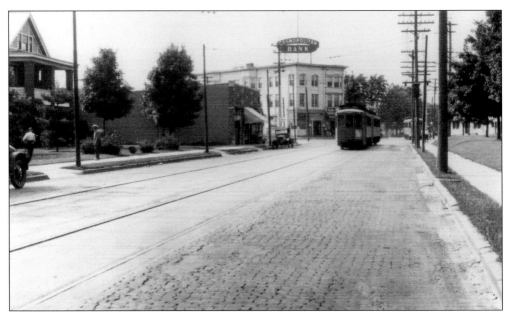

Dow Drugs, an early pharmacy owned by Cara Dow, stands in the center left building near Cosmopolitan Bank in Prout's Corner. In the early 1950s, the pharmacy was sold to Elmer Eisenecher, and Tom Hart later bought the store with help from George Rohe, Charlie Schwallie, and several wholesale drug companies. Hart opened Hart Pharmacy on February 29, 1960. In 1970, he hired Giles Blind, who had worked at the store when it was Dow Drugs.

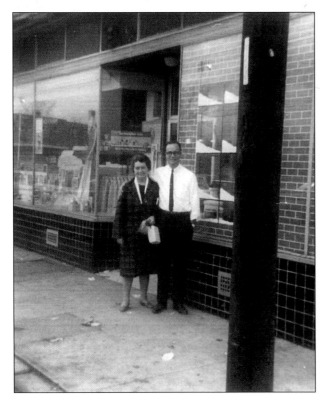

Tom Hart stands with his mother, Lil Hart Fey, on opening day of Hart Pharmacy, February 29, 1960. Hart was successful, and he bought other neighborhood pharmacies, including Shrivers, Rewwers, and Ballhaus. In 1990, Hart's daughter Mimi closed her store, Wolff Pharmacy, and became head pharmacist for Hart Pharmacy; her sister Aimee is the business manager. In 2008, they are the oldest pharmacy west of Vine Street to be owned continuously by the same family.

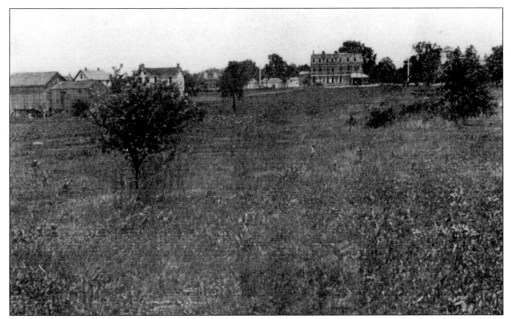

John Mueller's Roadhouse, Café, and Restaurant operated out of this distant building near present-day Prout's Corner (around 1912). An old tollgate used to stand on these premises, and the roadhouse was a popular place to stop for a bite to eat during one's travels. The restaurant also hosted evening dances and get-togethers.

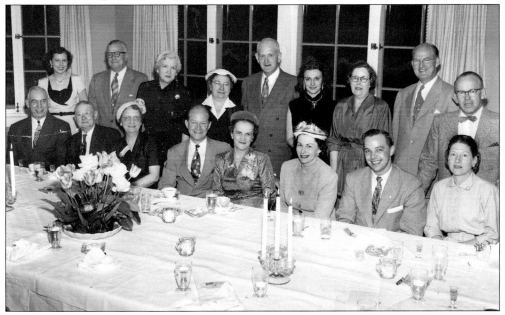

In the 1940s, the Price Hill Electric Building and Loan Association stood on Warsaw Avenue between McPherson Avenue and Wells Street. The company's board of directors included, from left to right, (first row) Erwin Moster, Gus Bemerer, Mrs. Moster, Bob Deters, Edith Deters, Mary Robben, Tom Robben, and Mrs. Pendergast; (second row) Loretta Gutzweiler, George Duwel, Mrs. Duwel, Alma Cook, Lawrence Cook, Katherine Barber, Ethelrita Flannery, Elmer Pendergast, and Jerry Hauck.

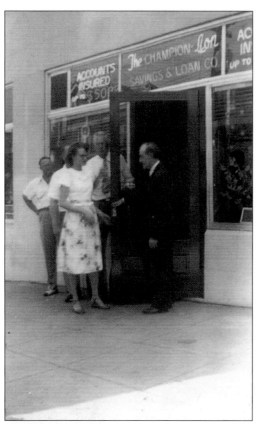

In 1948, the Champion-Lion Savings and Loan opened new offices at 4037 Glenway Avenue. Clarence A. Schnieders, secretary and attorney for the Champion-Lion Savings and Loan, stands on the far left; his daughter, Marcella C. Schnieders Peter, stands center; and William Weber stands on the far right. This savings and loan started as a *bauverein*—a German term for a place where members could pool their money to purchase items for the group's common good.

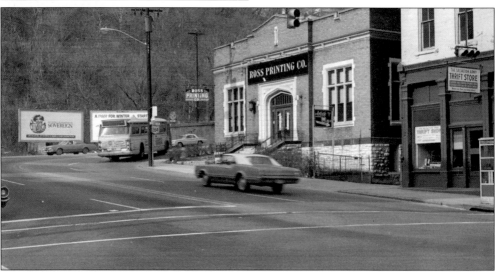

In 1941, Ross Printing was located at Ninth and Plum Streets in downtown Cincinnati, but it moved west to this location at 2306 West Eighth Street (on the corner of State Avenue) around 1954. Before Ross moved to this building, the West End Public Library was located here. The West End Public Library was the first Carnegie building built in Cincinnati, and the first one to be torn down. The Price Hill Boys Club was located next to Ross Printing and was one of the first such clubs in the country. In 2008, Ross Printing is no longer in operation.

Skyline Chili was founded by Nicholas Lambrinides and his three sons in 1949. He named his company Skyline because of the beautiful skyline he saw from his location on top of Price Hill. On April 16, 2002, locals were invited to a "last meal" at this first restaurant, located at 3822 Glenway Avenue. In 2008, the Price Hill Skyline Chili is located at 3714 Warsaw Avenue.

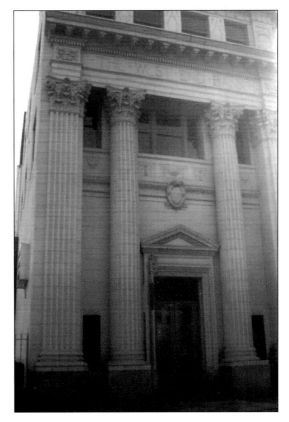

This building at the corner of West Eighth Street and State Avenue opened as the West End Bank around 1913. It was later owned by the Cincinnati Trust Bank and 5/3 Bank, then left vacant. Bill Burwinkel, who owns the National Marketshare Group, Inc., bought the building in 1996 and restored it. In mid-1998, it opened as the headquarters for his company. In 2008, the building is still owned by Marketshare, and the first floor still displays a mural by Charles Pedretti.

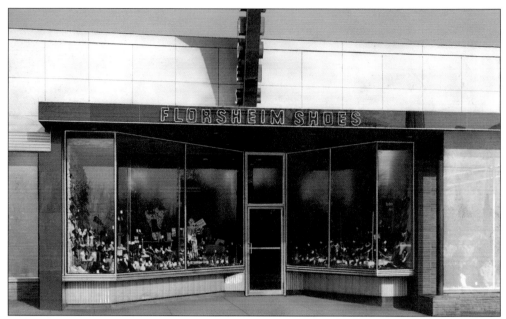

The first Marmer's shoe store was opened by Ida Levine Marmer on 4035 Glenway Avenue in 1925 and moved here (4102 Glenway Avenue) in 1950. In December 1923, Ida married Jack Marmer, a successful traveling shoe salesman. On October 3, 1924, Ida gave birth to Saul and proposed to her husband that she open a shoe store. If it was successful, she would hire him and he would quit traveling. The store was a success, and Ida hired Jack.

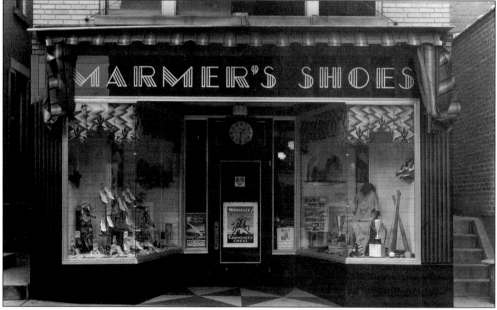

Two years later, Jack opened a second shoe store here at 3626 Warsaw Avenue, and the family lived upstairs. Also during this time, Jack started a second business selling orthopedic shoes out of the same location. On July 11, 1936, the Marmers' second son was born. The business continued to grow, and the Marmers started opening stores all around town. At their peak, they owned 12 stores.

Jack Marmer helps a female customer with his foot X-ray machine, which always found a customer's correct shoe size. Jack opened a third store in Price Hill on 3312 Warsaw Avenue and one in nearby Western Hills in the newly built Western Hills Plaza. Jack was instrumental in getting local residents to approve the building of the new shopping center. Saul continued the Marmers' shoe business, and Saul's son, Michael, continued in the orthopedic footwear industry.

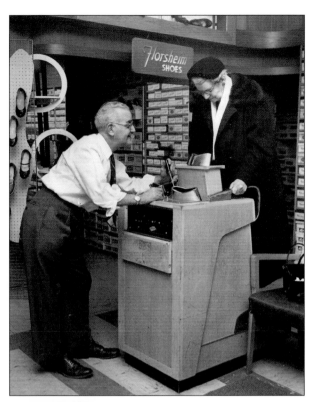

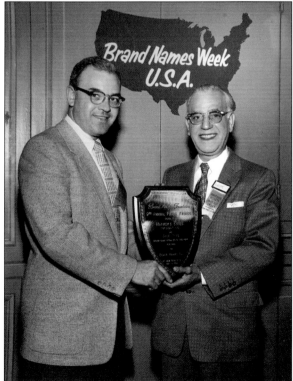

In 1959, Saul (left) and Jack (right) won Brand Name Retailer of the Year in a competition hosted by Brand Names Foundation. This award recognized the success a business had in promoting select brand names. Marmer's won for its business with brand name footwear and unsurpassed service. In 1957, it had won the third-place award, and in 1958, it won second place. In 1990, Marmer's Shoes closed.

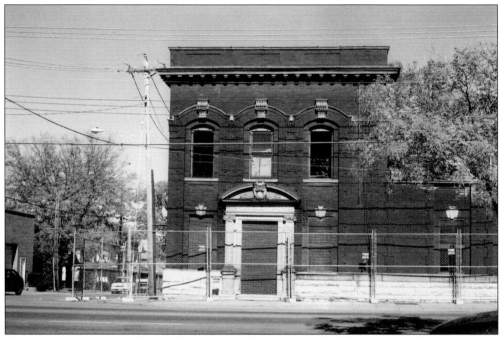

The Cincinnati Gas and Electric Company was located at 3452 Warsaw Avenue for many years. While Price Hill was home to many retail locations, it was rare for such a public works building to be in the area. In December 2007, this building was razed.

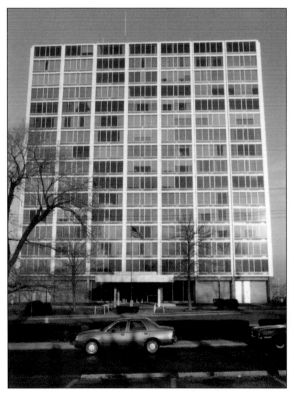

In 2008, the Queens Tower is located at Matson Place (at the corner of West Eighth Street and Mount Hope Road). This building is home to condominiums and Primavista restaurant—a classy Italian restaurant that was established in 1989. Before the restaurant and condominiums were built, Rees Price's home sat in this parking lot.

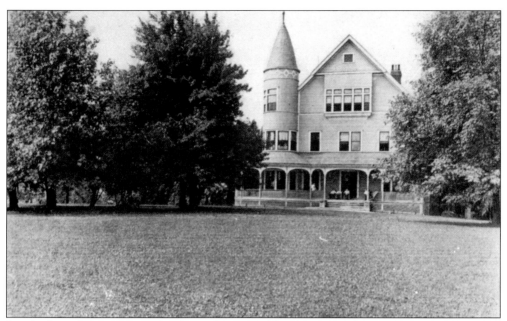

Jewish Convalescent Home was located at 4640 Rapid Run Road near Glenway Avenue. By 1950, this home had closed and was later razed. In 1855, 21 Jewish cemeteries existed in Price Hill, established by synagogues or mutual aid societies in the area. Many of them are still used for burials in 2008.

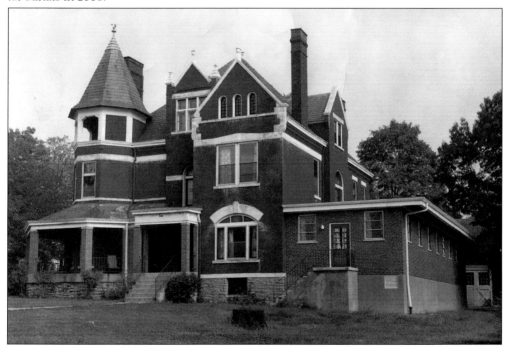

The Price Hill Nursing Home stands on the southeast corner of Elberon and Phillips Avenues. Lea Westerman bought the 14-room house from Philomena M. Overbeck with plans to turn it into a convalescent home. She added an addition to the house (shown on the far right) and opened for business. By 2008, the nursing home had closed, and this building remains vacant.

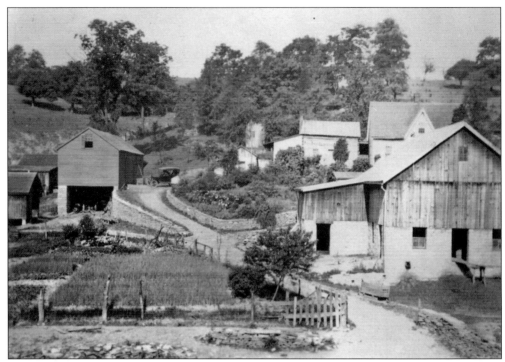

The above photograph represents a typical farm on the rolling landscape of Price Hill during the early twentieth century.

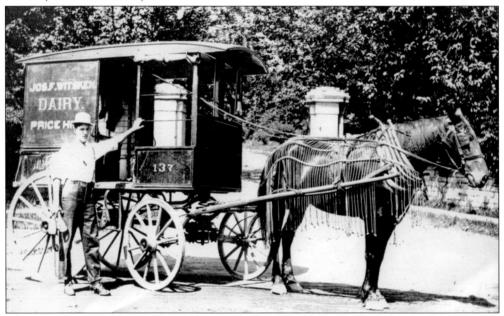

In 1870, Henry Messink bought property on Cleves Warsaw Pike and started a dairy farm. In 1910, Joseph F. Witsken bought the property and developed it into Witsken Dairy, a thriving dairy business that served the Price Hill area until 1950, when the dairy closed and the land was sold for the development of the Covedale Park subdivision. The Witsken farmhouse, however, still stands on Cleves Warsaw in 2008.

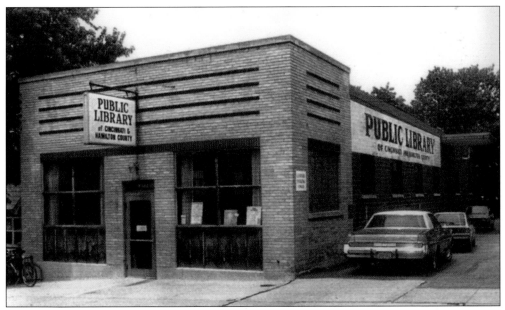

The Overlook Branch Library was originally built on November 25, 1935, at 4901 Relleum Avenue. On August 27, 1973, this branch moved to 4908 Heuwerth Avenue, shown here. In 1997–1998, the Public Library of Cincinnati and Hamilton County renovated the building shown below to open the Covedale Branch Library. (Courtesy of the collection of the Public Library of Cincinnati and Hamilton County.)

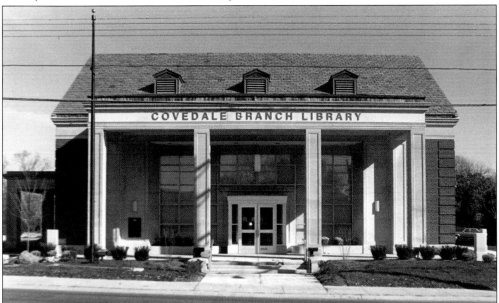

The Covedale Branch Library opened in its new location, 4980 Glenway Avenue, on January 9, 1998. Larry Schmolt helped encourage the creation of this new library. As president of the Price Hill Civic Club, he encouraged residents to write letters to the main Cincinnati library asking for a larger branch library on the west side of Price Hill. In 2008, the branch manager is Eileen Mallory. (Courtesy of the collection of the Public Library of Cincinnati and Hamilton County.)

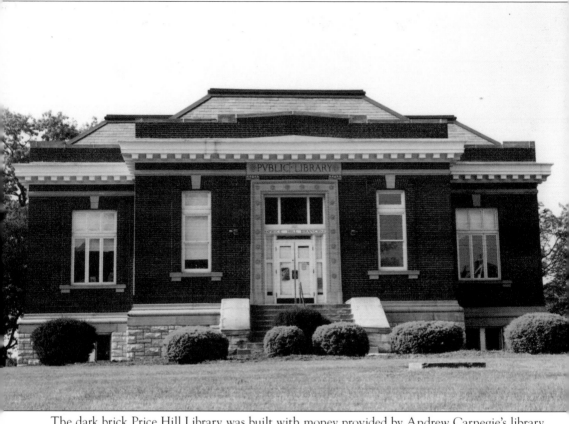

The dark brick Price Hill Library was built with money provided by Andrew Carnegie's library fund. The library cost $26,707.15 to build, and it opened on November 27, 1909. By July 1, 1910, the library had circulated an unprecedented 47,412 books and issued 1,677 library cards. The library featured an auditorium and hosted entertainment events. Various organizations also held their meetings at the library. The branch often sent books to the Good Shepherd Home for Girls, a local reformatory for women and girls, and provided a weekly supply of books and magazines to the engine house at the bottom of the hill. A yearly report also mentions that the members of the fire department closer to the top of the hill were regular members, so it was not necessary to deliver books to them. The library also served as a general meeting place for clubs and organizations. For instance, the library records state that the Price Hill Boys Club was organized on April 12, 1910, with 189 kids. In 2008, the library remains at 3215 Warsaw Avenue, and Elvia Tuttle is the current branch librarian. (Courtesy of the collection of the Public Library of Cincinnati and Hamilton County.)

Three

ORGANIZATIONS

The Price Hill Historical Society started in June 1990 and had 70 members by December of that year. The group met at the Dunham Recreation Center and then for a year or so at this building at 3642 Warsaw Avenue. For many years it met above Ed Horning's Piano Shop. Larry Schmolt was the first member, and early board members included Deborah Horning, John Pierok, Karen Hummer, Jo Ann Mallory, Dan Gruber, Valda Moore, and Betty Wagner.

On June 27, 2000, the Price Hill Historical Society moved into this building at 3640 Warsaw Avenue. Since its origin, the Price Hill Historical Society has published many books about the area, including *Price Hill: Preserving Yesterday, Today, for Tomorrow* and *A History of Seminary Square Eco-Village*. In 2008, the group remains on St. Lawrence Corner and remains very active by hosting home tours and exhibits.

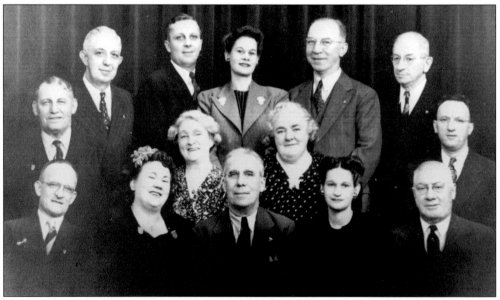

This picture of the Price Hill Civic Club was taken in 1943. From left to right are (first row) Leo B. Honerkamp, Mrs. Ed Stokes, J. T. Gallagher, Mrs. Sanders Taylor, and George Hock; (second row) William Siglock, Mrs. Joseph Brennan, Mary Stokes, and Robert Rafferty; (third row) Frank Pfister, Harry Harmeyer, Mrs. R. E. Single, A. J. Feldhaus, and Frank J. Kramer.

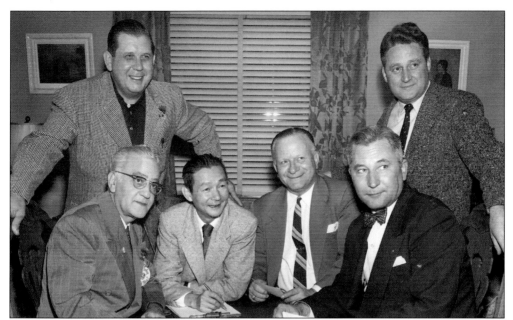

Members of the East Price Hill Improvement Association included, from left to right, Edward C. Goetz, Jack Marmer, Charles Yee, Howard Hillebrand, John Ruzman, and unidentified. Originally formed in July 1943 to save the Price Hill Incline, this group's mission was to promote the general welfare of the East Price Hill community. Many members were distinguished business owners. In 2008, the organization continues to exist; find it at www.ephia.org.

Edward C. Goetz was the president of the Price Hill Civic Club. The civic club celebrated its 50th anniversary in 1965 with a dinner/dance at Twin Lanterns, 6191 Harrison Avenue. Goetz, along with Fred J. Morr, the Hamilton County auditor, and Robert Jennings, the clerk of courts, spoke at the occasion. The Southern Gateway Chorus Barbershop Quartets of America performed, as well as Bill Scheffel's orchestra.

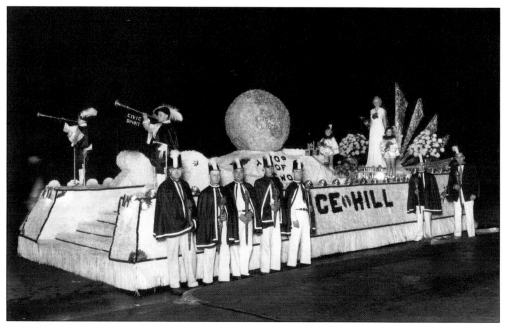

John Silbernagel built this float for the Price Hill Civic Club. Ray Silbernagel is on the front of the float. Big parades, such as this one, were usually held the night before Price Hill Day at Coney Island to drum up interest in attendance. Another big parade event is the Price Hill Thanksgiving Day parade.

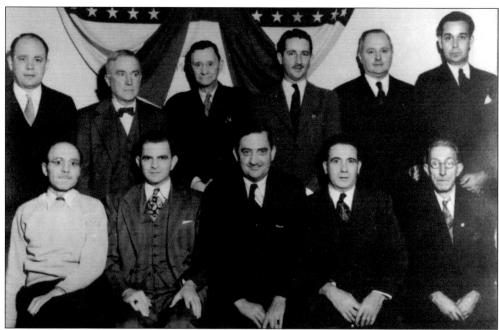

Members of the Price Hill Civic Club gather for this picture. From left to right are (first row) Frank Catanzaro, Robert J. Buchert, Theodore Steinke, unidentified, and Robert Cox Stump; (second row) Elmer Lanyen, Charles Haap Sr., Al Moemke, Charles Haap Jr., Walter Buchert, and Ralph Meyer.

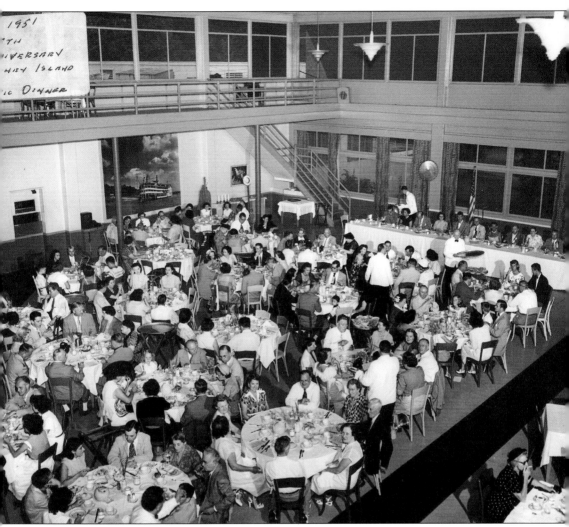

This picture was taken in 1951 at the Price Hill Civic Club 35th anniversary dinner at Coney Island. This year, Ralph Quinn became president of the club. He joined in 1941 and was a director on the board for several years. The club hosted Price Hill Day at Mount Echo Park and Coney Island, plus a summer family picnic hosted in Delhi picnic groves (such as Lauterbach's Grove and Green's Woods). Later Quinn organized the biggest Price Hill Day parade ever held. During the parade, Quinn played calliope music he had recorded from the *Island Queen* steamboat. Because he was so active in the community, Quinn was nicknamed Mr. Price Hill.

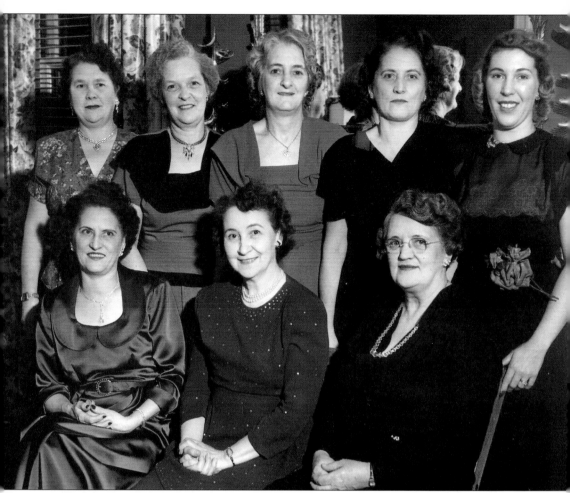

Officers in the Price Hill Women's Club in 1951 are, from left to right, (first row) new officers Mary Clark, vice president; Philora Burger, president; and Molly Kermon, secretary; (second row) Elsie Gibbs, secretary; Lillian Minnery, director; Irma Trame, director; Marie Meyer, past president; and Ruth Schmidt, publicity. The Price Hill Women's Club was formed by Ruth Booth in 1936 during the Great Depression. The group held card parties to raise funds for local organizations and charities and performed skits at hospitals and institutions. It donated to the Mount St. Mary's Training School for Girls, Little Sisters of the Poor, the Hamilton County Tuberculosis Hospital, Symphony Project, the civic club, St. Francis Hospital, the community chest, and other organizations and charities. It also sold almost $200,000 in war bonds and mailed 2,200 cards and gifts to servicemen and servicewomen. In 1986, the women's club celebrated its 50th anniversary and then disbanded due to a loss of interest from members and the increase of government-funded programs offering similar help.

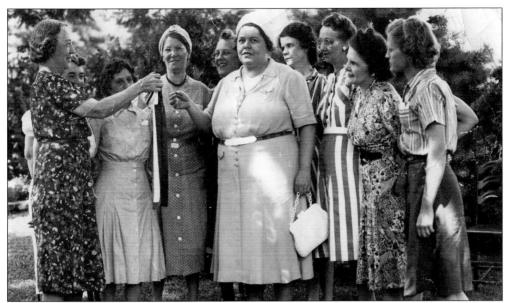

The Price Hill Women's Club, in 1940, included (from left to right) Adele Meyer, Sadie Hammen, Delia Squire, Mary Heitz, Mildred Pearsen, Catherine Smith, Ruth Sampson, Elsie Stehr, Ada Steele, and Veronica Huber. In 1945, the similar Women's Price Hill Civic Association converted an old firehouse at Warsaw and Considine Avenues into a community center. In 1985, with help from councilman John Mirlisena, Howard Hillebrand, and Gloria Morgan, this community center moved to Hawthorne Avenue, where it stands in 2008.

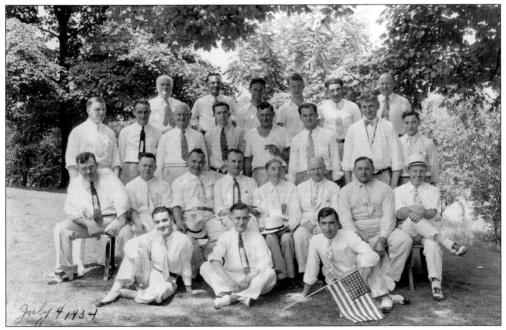

The Price Hill Businessmen's Club gathered on July 4, 1934, for its annual picnic. In 2008, local organizations still are a big part of the Price Hill community spirit. Many groups are still thriving, and some that used to be integral to the community, including the Price Hill Women's Club, are not.

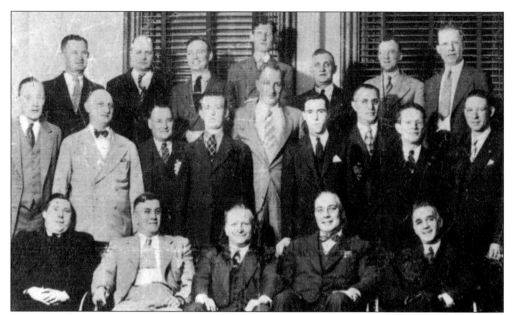

The Price Hill Businessmen's Club in the 1930s included, from left to right, (first row) Victor Paff, John Lambert, Howard Hillebrand, Fred Mohr, and Jack Marmer; (second row) B. Westendorf, Al Koch, L. Kessler, J. Rottinghaus, C. Coddington, C. Busch, C. Fledderman, A. Berkemeyer, and S. Grady; (third row) F. Pendergast, B. McManus, O. Rottinghaus, F. Duwel, F. Kunkemiller, and two unidentified men.

The Price Hill Salvation Army was first located at the corner of Eighth Street and State Avenue and then the corner of Warsaw and Fairbanks Avenues. By 1927, the Salvation Army had moved to 4017 Glenway Avenue, where it stayed until at least 1985. This land is now owned by Elder High School. The Price Hill Salvation Army then built this building at 3503 Warsaw, where it continues to operate in 2008.

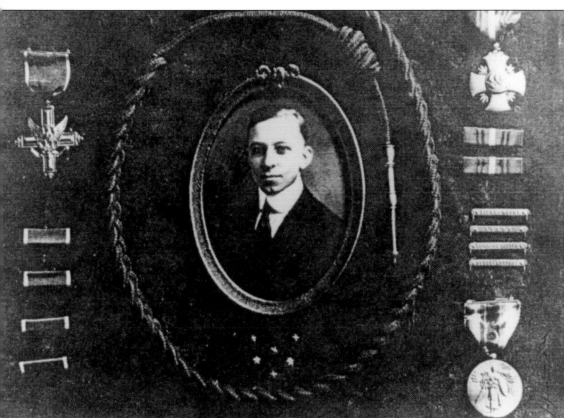

George W. Budde, shown here, lived at 228 Laurel Avenue in the West End. His parents were George J. and Elizabeth. George W. was born in 1895, and his brother Norbert was born in 1905. The next year, the Buddes moved to 638 Hawthorne Avenue, and in 1908, they moved to 655 Hawthorne Avenue. The family attended Holy Family Church and School. In 1917, George W. enlisted in the military, and the next year he was wounded in the shoulder at Belleau Woods, France. Still he went back to fighting on the front line. On November 11, George W. died in the battle at Ville Montrey, France. This battle took place just a few hours before the armistice that ended World War I was declared. George W. was laid to rest at the old St. Joseph's Cemetery, and a military parade for him ended at Holy Family Church. George W. Budde was posthumously awarded the Distinguished Service Cross on February 16, 1925.

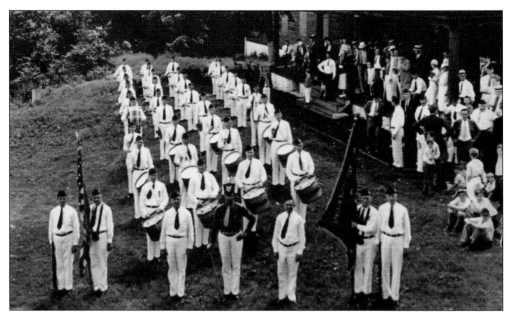

The George W. Budde Post of the American Legion celebrates in 1935. The post had just formed two years earlier on January 19 and was named in George W.'s honor. At this first celebration, Judge Thomas Morrow, Thomas Gallagher, and Norma White Walburg participated in the festivities. In 2008, members continue to decorate the graves of war veterans in both the St. Joseph cemeteries on the Saturday before Memorial Day.

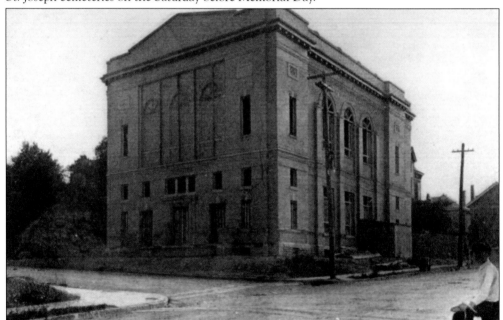

This picture shows the Masonic temple at Price and Purcell Avenues before it was finished. This building was completed around 1912. The Price Hill Masonic Lodge No. 524, Free and Accepted Masons, met here, although it is possible other groups met here as well. The Price Hill lodge was formed in 1882, making it one of the first secret societies in Price Hill. The group still exists in 2008.

The Price Hill Kiwanis Club celebrates during one of its annual elections. Jack Marmer, shown sitting on the far right, was heavily involved in many Price Hill clubs and social organizations, including this one, the Price Hill Civic and Businessmen's Club, and the Old Timers'. Jack's wife, Ida, was a member of many women's civic organizations and social clubs.

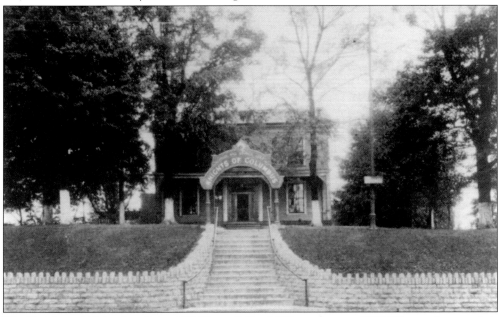

The Knights of Columbus Price Hill Council No. 1359 met here at 3509 Warsaw Avenue. It is thought that this building stands on the same grounds as the original log cabin home of William Terry and his family, the first family to settle in Price Hill in 1791. This building was torn down by 1959.

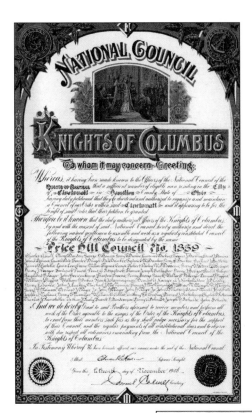

This charter for the Price Hill Council of the Knights of Columbus shows the council was officially formed on November 15, 1908. Many Catholic men in the community worked to form this council, including the first grand knight, Joseph A. Niehaus. But by 1941, this council had dissolved.

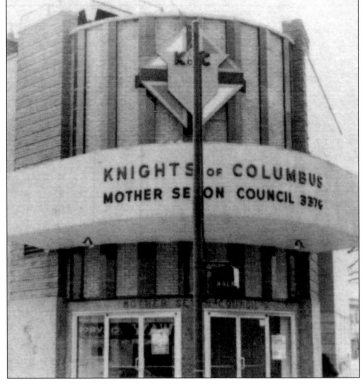

On Thursday, September 21, 1950, a new Knights of Columbus council held its first meeting, and on January 14, 1951, the Mother Seton Council No. 3376 was instituted in Price Hill. The group first met in the St. Lawrence Church music room and in 1959 used the vacant Sunset Theatre as its hall. In 2008, this Knights of Columbus council is located at 4109 West Eighth Street.

Four

PRICE HILL NEIGHBORS

Rees Price was born on August 12, 1795, grew up on the hills of Cincinnati, and also invested in land. His name is often misspelled as *Reese*; however, in looking at bills signed by Rees himself, there is no *e* on the end of his name. His parents, Evan and Sarah Price, arrived in Cincinnati in 1807. Evan, a Welsh merchant, and Sarah were living in Baltimore before moving to the west side of Cincinnati.

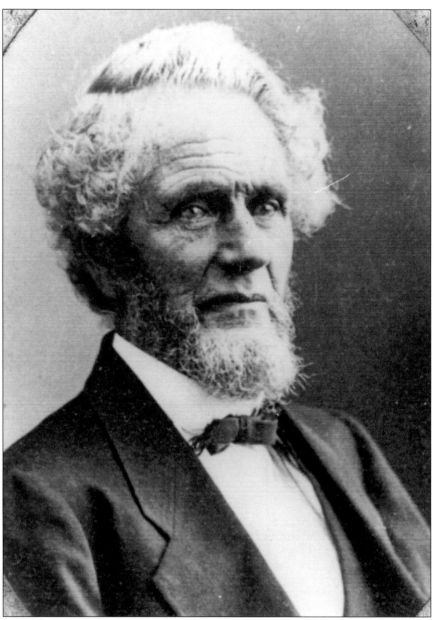

On December 9, 1824, Rees Price (shown here) married Sarah Matson, daughter of Judge Matson, and the couple had eight children. Thanks to this pioneering family, the burgeoning area became known as Price's Hill. Price's land and the village of Warsaw merged into one community during the late 1800s. Another early nickname for this area was Fruit Hill because of the many orchards planted by the first settlers. Since the hilltop land was high above—and away from—the city, which was often dusty and dirty, many wealthy citizens moved to Price's Hill and built extravagant homes. However, the route to the area was difficult. Rees's sons, John and William Price, continued to develop the area now known as Price Hill, and they helped build the Price Hill Incline in 1874. Rees opened a brickyard and sawmill to accommodate potential builders, and the business took off. Rees's son William was instrumental in developing and building the Price Hill Incline. Both Rees and Sarah Price are buried in Spring Grove Cemetery.

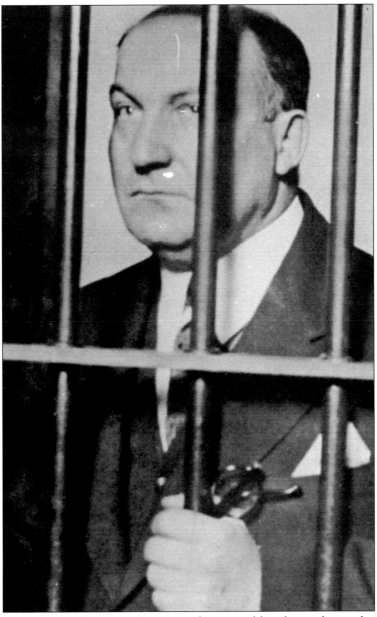

Legend has it that George Remus, a Cincinnati lawyer and bootlegger during the Prohibition era, may have been F. Scott Fitzgerald's inspiration for the character of Jay Gatsby in *The Great Gatsby*. Remus was convicted of tax evasion and spent two years in jail. During this time, his wife Imogene and the treasury agent who had investigated him, Franklin Dodge, had an affair. The couple liquidated Remus's assets. On October 6, 1927, Imogene was driving through Eden Park, on her way to finalize her divorce, when Remus, who had just been released from jail, shot and killed her. Remus was tried for his crime, served as his own defense attorney, and was found not guilty by reason of insanity in less than 20 minutes by the sympathetic jury. He spent just a few months in an asylum in Lima, Ohio. When released, he tried unsuccessfully to get back into bootlegging but later worked as a real estate developer and spent the rest of his life in nearby Covington, Kentucky.

In 1835, Peter Neff Sr., shown here, came to Cincinnati with his brothers, John, Rudolph, and George. They established the Peter Neff and Sons hardware shop. In 1878, his son Peter Rudolph cofounded the College of Music with George Ward Nichols and Reuben R. Springer. Peter R. was also the president of the philharmonic orchestra and was very involved with the Cincinnati May Festival, among other events.

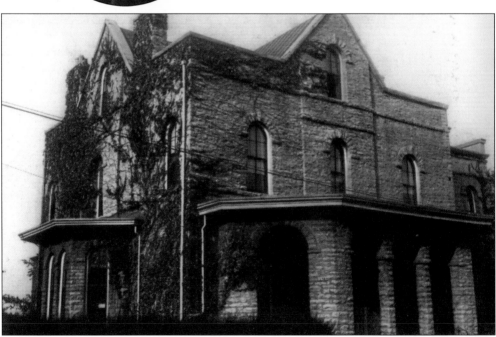

Both Peter R. and William Neff settled in Price Hill, with William building this grand house at 2588 Ring Place. His brother Peter R. lived within sight of his house, which was separated by a creek (now Glenway Avenue). William was one of the founders of Spring Grove Cemetery, where both he and his brother Peter R. are buried.

Peter R. Neff donated his house at 2700 Glenway Avenue, shown here, to start the Grandview Sanitarium in 1901. The sanitarium cared for those with mental disorders and addictions to alcohol and/or drugs. The Cincinnati Bible Seminary (now Cincinnati Christian University) has occupied these grounds from 1939 to the present day. In May 1974, Neff's descendants presented a plaque to the seminary. The Neff home was razed, despite protests, on July 28, 1997.

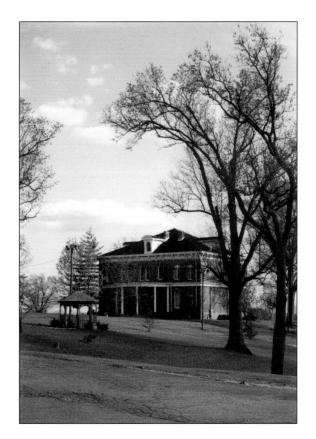

Ted Grofer stands in front of the women's building at the Grandview Sanitarium. Peter R. Neff, whose home became the sanitarium, was also the business manager of Grandview. The nursing staff lived on the sanitarium grounds, and patients were treated by Dr. Brooks Beebe. Later sanitarium operation was taken over by Drs. Joseph M. and Thomas A. Ratliff, and it remained open until the late 1920s. Even after it closed, the property was used to board Coney Island ponies. The Cincinnati Bible Seminary purchased the property in 1939.

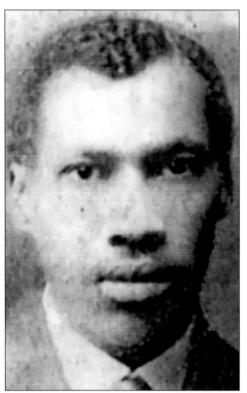

Raymond Garfield Dandridge was a prolific Price Hill poet who became known as the Paul Lawrence Dunbar of Cincinnati. He wrote *Penciled Poems* (1917), *The Poet and Other Poems* (1920), and *Zalka Peetruza and Other Poems* (1928). Born in 1882, he attended Hughes High School where he competed as a runner and a swimmer. In 1911, a fever left him partially paralyzed, and he lived with his mother at 811 Chateau Avenue. He died in 1930.

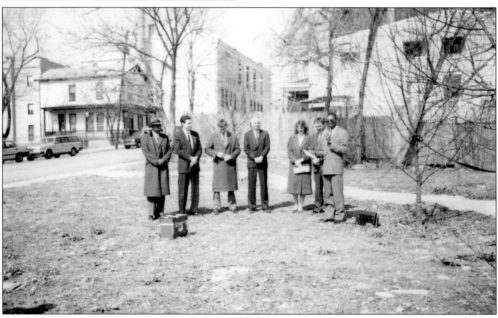

In 1999, residents congregated to dedicate the Dandridge Gardens in East Price Hill. Built on property donated by Dr. Eileen Adams, Incline Properties, and Ameritech Mobile Communications, this garden is in memory of Raymond Garfield Dandridge, the famous Price Hill poet. In 2008, the garden still stands at the northeast corner of Grand Avenue and West Eighth Street and is maintained by the Whittier Garden Foundation.

Clement Niehaus, shown here, was born in 1923, grew up in Lower Price Hill, and later moved to Purcell Avenue. He worked for Heilman's store on West Eighth Street in Lower Price Hill. Mr. Heilman sold his store to Niehaus and his mother in 1927. Niehaus's store survived the Great Depression since the City of Cincinnati bought shoes for the poor from his store. Still, he says sometimes he just made 15¢ a day.

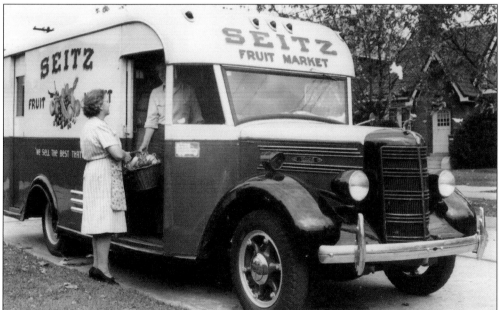

Loretta Niehaus and her son Bob (pictured here) worked at the Seitz family fruit market. In 1978, Bob bought his father's shoe store and in 1986 resold the building to the city for redevelopment purposes, with the contingent that the rent not be increased greater than $50 a month. In 1990, Clement retired from the shoe business, and the building was razed in February 1993. Clement died the next year.

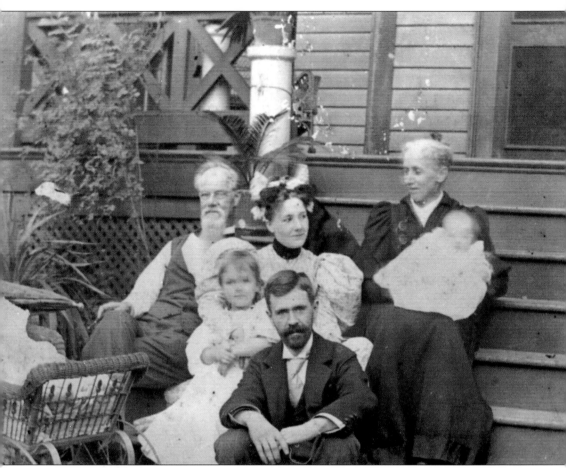

Warren Wilder (1831–1919) was an early Price Hill resident and is on the far left of this picture with the gray beard. This picture was taken in 1896. The others in the picture are Kate Margua Wilder in the back, holding baby Gena Caven (born on April 22, 1896). In the center, clockwise, are Alice Caven, Fannie Coe Wilder Caven, and George M. Caven. George and Fannie married March 23, 1892. They were the parents of Alice, Gena, Robert, and Augusta. Warren's parents were Stephen and Elizabeth Wilder. They lived in a grand 12-room mansion at 2512 Morrow Place that they had built in 1864 replacing an earlier home. This home was demolished in 1974. Stephen and Elizabeth had 10 sons, the youngest of whom was Edwin Forrest Wilder. The Price Hill Historical Society has a fairly complete ancestry of this family.

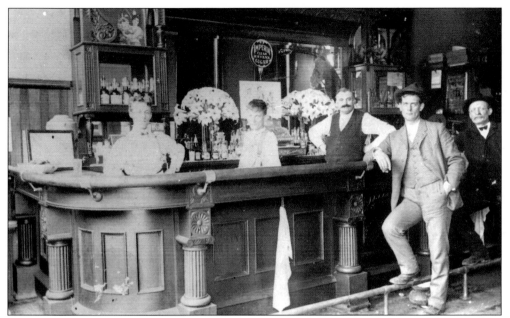

The John Doll saloon stood at 4519–4521 West Eighth Street. This picture was taken in 1896. From left to right behind the bar stand William Havins, Charles Doll, and John Doll. At the far right of the picture stand two unidentified people. John's relative Jack Doll was an excellent photographer. He married his wife, Ruth, in 1964, and the couple lived in Price Hill on Overlook Avenue until Jack's death in 2008.

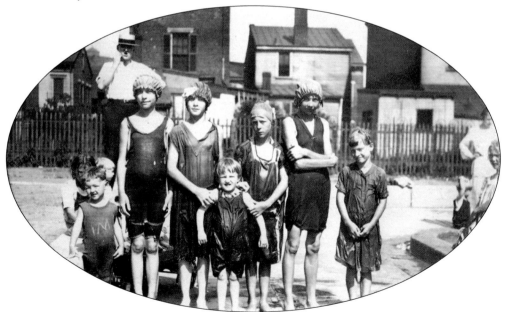

The Kalish family goes swimming at the Oyler Pool, right behind Oyler school. In the 1920s, there were four other swimming spots in the area: the Falls (at Muddy Creek and Rapid Run Roads), the Ohio River (although that was already polluted, and children were discouraged from this option), at George Remus's mansion (where entry was gained either by invitation or by sneaking in), and the Wells Street pools at the 700 block of Wells Street.

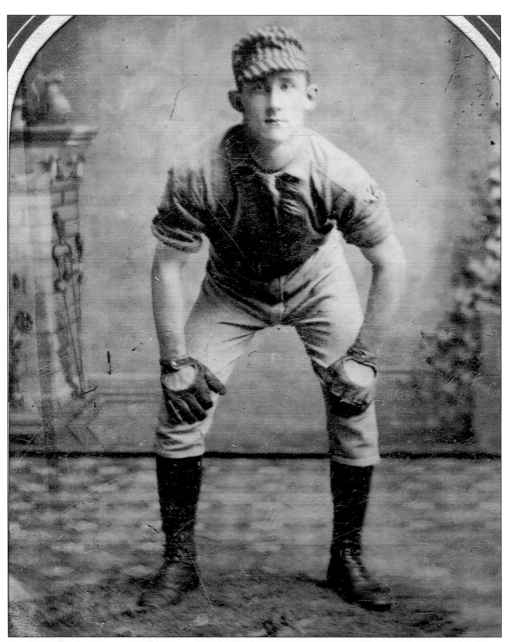

Andy Gallagher was a well-known baseball player in the Price Hill area. Born in the West End around 1870 to Irish parents, Gallagher played catcher for a local baseball team while also working at the American Oak Leather Company for 4¢ an hour. Later the family moved to Price Hill and joined Holy Family parish. Gallagher would often attend the early mass at Holy Family with his baseball glove. After mass, he would go to the field and play pickup baseball games. At that time, catcher was an unpopular position, so Gallagher often played catcher for both teams during one game. In 1962, he became the first baseball player inducted into the Price Hill Old Timers' Hall of Fame. He played well into his 70s. He died at 90 years old on August 5, 1960. Each year, the Old Timers' association presents a plaque to an outstanding athlete from both Elder and Western Hills High School at a celebratory luncheon.

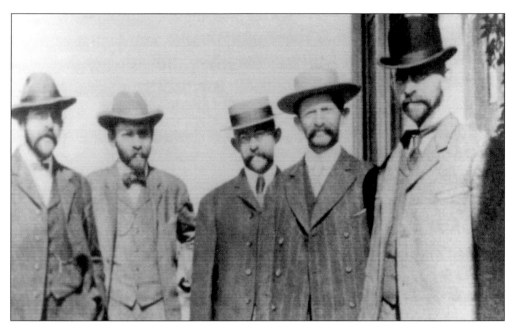

The Babbitt brothers ran a small grocery store selling fruits, meats, and vegetables in the late 1800s. The shop stood on the corner of Price and Summit Avenues and still stands in 2008. The Babbitts lived here from 1875 to 1885. Around this time, the Babbitt family moved to Arizona, where they opened a grocery store and named it the Babbitt Brothers Mercantile, which still exists as the Babbitt Brothers Trading Company.

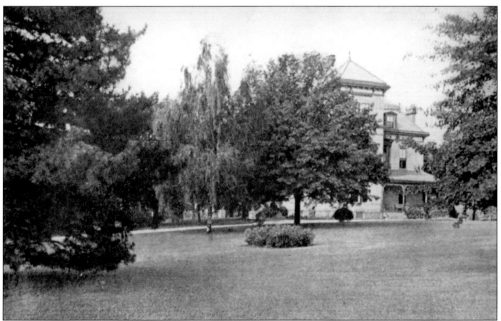

John A. Kreis lived in this home on Rapid Run Road and Glenway Avenue with his wife, Emma Schiff Kreis. A street in Price Hill today is named after this early pioneering family, which lived in Price Hill while it was a burgeoning neighborhood. Around 1954, the Sonia apartments were developed on this land, and they were located at 4609 Rapid Run Road.

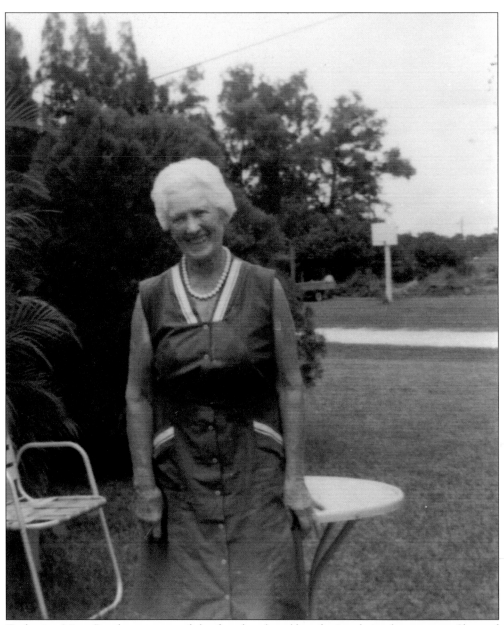

Catherine Mary Brophy was one of the first female golf professionals in the country. She and her husband, Ed, were both employed as golf professionals at the Western Hills Country Club (WHCC) for many years. In fact, most Price Hill residents knew them as Uncle Ed and Aunt Kate. Kate was born in Ireland and came to America in 1901. She married Ed in 1915 and took up golf a year later. She was 30 when she started playing and came in second in her first tournament in 1922. She went on to win many more competitions, including the Greater Cincinnati Women's Amateur Tournament three times (from 1927 to 1929). Ed was born in Cincinnati in 1883 and became a golf professional at 19. He started working at the WHCC in 1912 and worked there until his retirement in 1952. The couple continued to work as golf instructors during the winter in Sarasota, Florida. Ed passed away in March 1973, and Kate died a year later in May, both while still living in Sarasota.

The gravestone of Patrick McAvoy can still be seen in the new St. Joseph's Cemetery. McAvoy was regarded as a hero because of one courageous act in 1875. Before the Cincinnati Zoo opened on September 18 of that year, a lioness escaped her cage and attacked a donkey. After several workers tried, and failed, to capture the lioness, McAvoy shot the lioness. The story was widely reported, and McAvoy was heralded for his bravery.

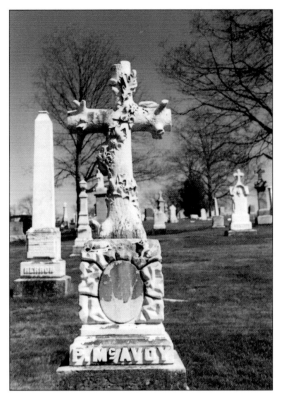

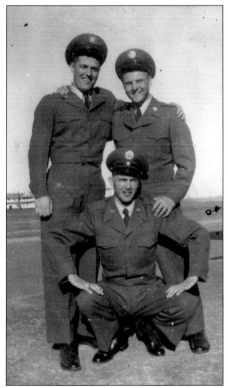

This photograph shows two Price Hill residents who were stationed at a U.S. Air Force base in California in February 1951. The serviceman at left is unknown, but on the right stands Al Wiener, and in the front is Tom Trame, who owned Phillips Dry Cleaners on Glenway Avenue for many years.

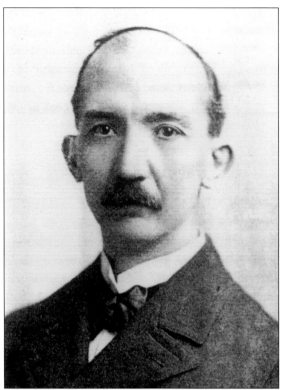

Hon. Edward J. Dempsey was a judge of the Superior Court of Cincinnati. He grew up at 551 Purcell Avenue. Dempsey was elected the city's mayor from 1906 to 1907 to break the hold of the infamous George "Boss" Cox, a corrupt politician. Dempsey lost the election the next year, but in 1917, he served as a member of the charter commission to help clean up the city's government.

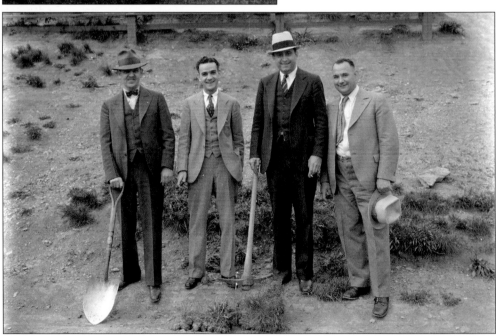

These men smile during the dedication of Dempsey Park around 1924. From left to right stand George Dirr, owner of a hardware store that was on 3626 Warsaw Avenue, Jack Marmer, Earl Westerfeld, and John Silbernagel. In 2008, the park still stands in his honor at the corner of Price and Purcell Avenues.

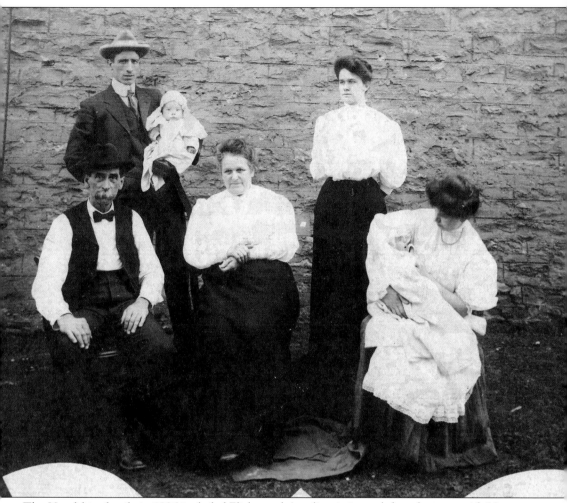

The Hotchkiss family in 1906 included Elisha and Amelia, sitting at left and center, with Harry Lenz holding his son, John Harry, and his wife, Pearl Hotchkiss Lenz, standing. Ellanore Imholte Hotchkiss is seated at right holding her son Walter R. "Bud" Hotchkiss. The photograph was probably taken by Ellanore's husband, Charles Walter Hotchkiss. Elisha Hotchkiss and his son Charles Walter worked as carpenters in the late 19th and early 20th centuries and at this time lived in a house they had built on what is now Manss Avenue. In 1913, the family moved into a carriage house on Lick Run Road, which is now Sunset Avenue. Elisha and Amelia had two other children, Clifford Denison and Lillie Margaret, not pictured here. Charles and Ellanore also had two daughters, Lillian Lenore and Dorothy Amelia, as well as Bud, who followed his father and grandfather into the building trades before opening a tavern, the Ideal Café, in the early 1930s.

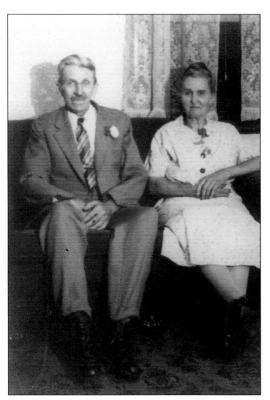

William and Mary Juergens, shown here, lived at 4434 Glenway Avenue. A master builder, William built local homes for 40 years and in 1900 built St. John's United Church of Christ on Neeb Road. He was also a member of the Warsaw Mutual Aid Society and was on the Glenway Loan and Deposit Board of Directors. William died in 1937, and his son, Clifford, took over the family contracting business.

William Juergens built his Victorian-style Glenway Avenue home in 1902 and added a carpenter's shop in back. The Juergens family lived in this house until selling it in 1971 to William and Betty Scott, who later sold to Mark and Cynthia Padilla in 1976. In 1989, Ed and Deborah Horning bought the house and started restoration work. Ed operates a piano service shop in the building that was Juergens's carpenter's shop.

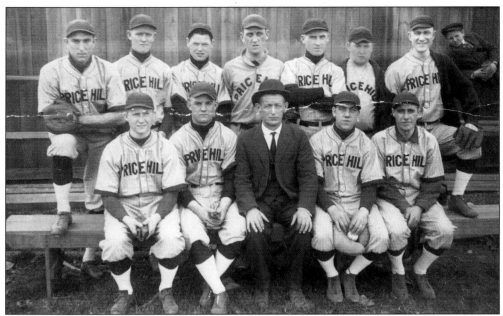

A Price Hill baseball team poses for a picture around 1917–1920. Other ballparks in the area could be found at Mount Echo Park, Dempsey Park, and a park at Kellywood Avenue and Guerley Road and Red Oaks, which was at the end of Manss Avenue. John Mueller, who owned the Covedale Exchange Saloon at Cleves Warsaw Pike and Glenway Avenue, ran a fenced-in ballpark on the same corner.

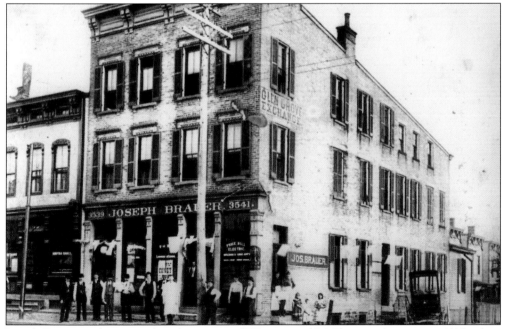

Joseph Brauer's saloon stood at the corner of Warsaw and McPherson Avenues in 1895, when this picture was taken. The back room of the saloon was a meeting place for many local clubs and organizations. The Price Hill Electric Building and Loan Association, later to become the United Savings Association, operated out of this building.

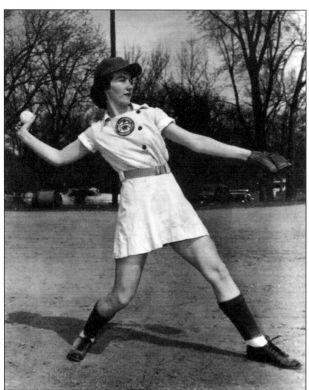

Marie Wegman played professional baseball for the All-American Girls Base Ball League from 1947 to 1950. It was her dad, Clem, who taught her everything she knew about baseball. In 1944, Marie tried out for the Amateur Softball Association Girl's League and was offered a $60 contract to play in the All-American Girls Base Ball League. She and two other players originally refused but later accepted the offer. Marie, Dottie Mueller, and Marti Hayes all signed.

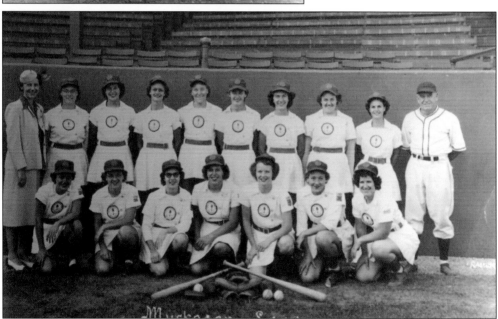

Marie's first stop was Havana, Cuba, for practice, then an exhibition tour from Florida to the Great Lakes area. From 1947 to 1950, she played for the Rockford Peaches, Fort Wayne Daisies, Muskegon Lassies, and a Grand Rapids team. After this, she continued playing and coaching baseball at St. Martin of Tours (in Cheviot), Holy Family, and St. Lawrence parishes. Many in Price Hill know her simply by her nickname, Blackie, because of her black hair.

Erwin C. Hoinke Sr. opened his bowling alley around 1943. The lanes stood on Glenway Avenue across from Seton High School. During the 1960s, the alley grew so popular that additional lanes were opened at its present-day location at 6383 Glenway Avenue and its name was changed to Western Bowl. By 1970, the Price Hill location was closed completely, and all events were held at the new location. In 2008, the bowling alley still operates.

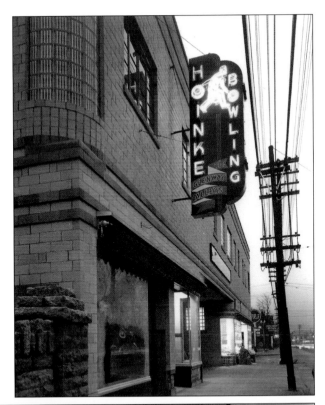

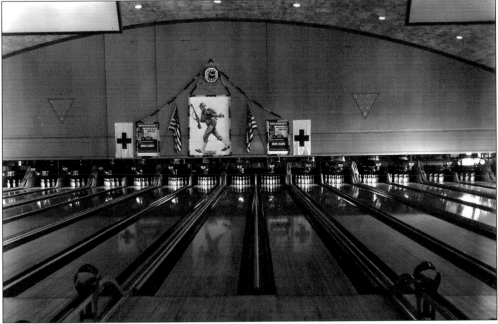

Hoinke and his business partner Clarence Stegner founded the national Hoinke Classic bowling tournament in 1943 to support both the war effort and bowling. Bowlers came from all locales to participate, and the winners were awarded with war bonds and stamps. The tournament continues today, and it is estimated that more than $1 million has been awarded.

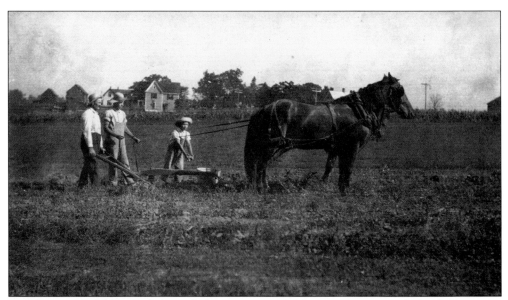

Fred Brater Sr. (1867–1942) farmed the area east of Glenway Avenue and the fields to the north and south down to Muddy Creek. He is shown here (in a photograph taken by his daughter, Laura Brater Reidel) with sons Carl Brater (center) and Fred Brater Jr. (right). Reidel was an accomplished photographer, winning a *Cincinnati Times-Star* contest with one of her photographs.

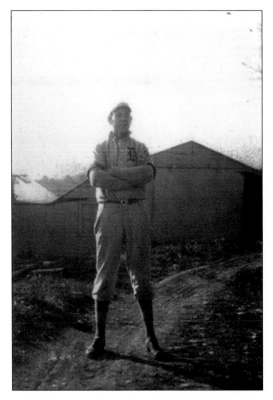

William Reidel (1889–1962) stands proudly in baseball uniform. Willy, as he was called, played baseball for Price Hill and Delhi semiprofessional teams before World War I and for a club in the St. Louis Browns farm system. The Old English *D*, similar to the Detroit Tigers logo, may stand for Delhi. (Photograph by Laura Brater Reidel.)

Souvenir photographs like this were made at Coney Island and Chester Park. Taken around 1915, Mary Reidel Johnson sits to the pilot's left, and on her left is her husband, the baker Fred Johnson. Mary's sister Carrie Reidel is at the far left, with her son Benni Reidel, a carnation grower, next to her. The other people in the photograph are not identified, but they are family or friends of the large Reidel family.

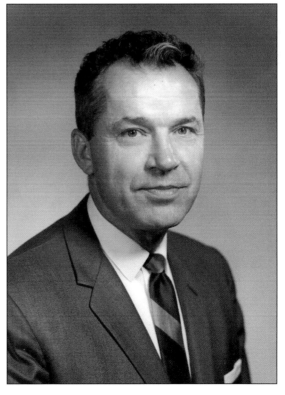

James J. Hausman grew up in Price Hill during the 1920s and served as a colonel in the United States Air Force. He worked in intelligence and briefed former president Dwight D. Eisenhower at times. In 1973, Hausman started writing "When I Was a Boy," short reflections on life, for the *Cincinnati Enquirer.* This syndicated column appeared in national newspapers five times a week and was collected into two books under the same name.

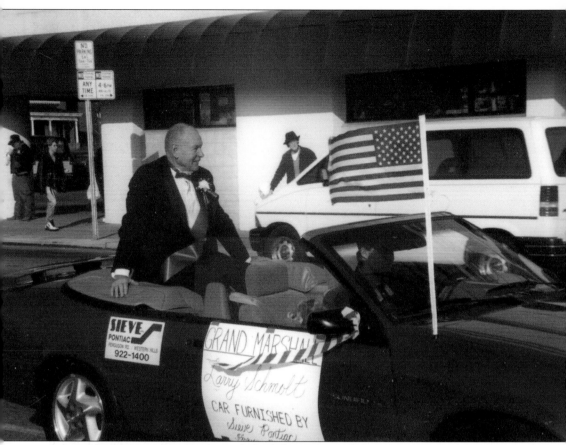

Larry Schmolt was the grand marshal of this Price Hill parade in 1993. Schmolt was the president of the Price Hill Civic Club and also was one of the founding members of the Price Hill Historical Society. His parents, Lawrence Schmolt and Marie Mitchell, were longtime west siders. In fact, Lawrence was named after St. Lawrence Church. He married Marie Mitchell (born on August 13, 1894, on Sedam Street in Sedamsville) on August 31, 1922, at St. Vincent de Paul Church. The family lived on Purcell Avenue and attended Holy Family Church and School. On May 28, 1951, Marie died, and Lawrence passed away on November 11, 1955. Their son Larry graduated from Elder High School and married Lee at St. Mary's Church on April 26, 1952. The couple had three daughters: Kathy, Mary Ann, and Pam. Larry worked for 30 years as a Cincinnati firefighter and retired as an assistant chief. Larry continues to be very active in the community.

This picture is of the Flying Eagle Patrol Boy Scout Troop 136 at a Harrison Tomb campout in August 1935. From left to right are (first row) Tom Hautman, Jack Doll, Bob Fenning, Charles Leachman, and Herman Boeing; (second row) Don Jaspers, Joe Murray, Joe Costa, Bob Hautman, and Phil McGill. This Boy Scout troop was sponsored by Elberon Presbyterian Church at 1009 Overlook Avenue.

Howard Hillebrand (left) accepts a signed baseball from Lee Grissom, a Cincinnati Reds baseball pitcher, on Friday, August 6, 1937. A native Price Hillian, Hillebrand was active in the Price Hill Historical Society, the Price Hill Civic Club, the East Price Hill Improvement Association, and more. In 1963, he was awarded the Man of the Year Award in Civic Life for Hamilton County for his lifelong commitment to the community. He died on March 25, 1997.

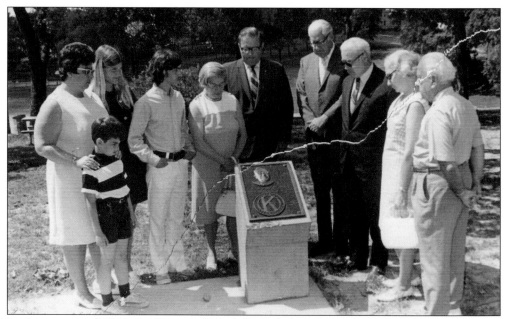

In the summer of 1970, the Kiwanis Club dedicated this memorial plaque to Jack Marmer for all his efforts to better life in the Price Hill area. In this picture stand, from left to right, Phylis Marmer (Saul's wife) and their children Johnny, Lynn, and Michael. Ida Marmer stands behind the plaque, next to, from left to right, Bill Stoutberg, unidentified, Saul Marmer, Esther Rissover (Jack's sister), and Morris Marmer (Jack's brother).

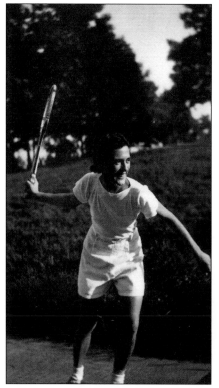

Ruth Hoebbel was a star tennis player. This photograph was taken around 1937. Hoebbel won many Cincinnati Recreation Commission tournaments as a singles and doubles player during the 1930s and 1940s. She lived most of her life at 3412 Beaumont Place across from Mount Echo Park, where she taught many neighborhood children the finer points of the game.

At age 16, Henry W. Meyer worked as an illustrator of horse-drawn vehicles and harnesses for trade catalogs at the F. C. H. Manns Company. At age 24, he became vice president of the organization and later established the Meyer Engraving Company. He retired in 1950 at age 71 and researched, wrote, and printed *Memories of the Buggy Days*, a history of the carriage industry.

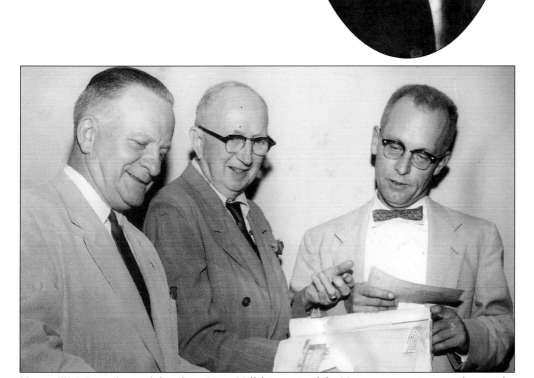

Henry W. Meyer (center) lived in Price Hill his entire life. He was an active member in the Price Hill Civic Club, the Hamilton County Federation of Civic Clubs, the Price Hill division of the Senior Citizens Club, and the East Price Hill Improvement Association, of which he was president, and was a delegate to the Western Hills Civic Planning Council. He celebrated his 90th birthday in good health in October 1969.

Patrick and Mary Dugan, shown in this picture, raised seven children: Florence, Helen, Martha, Bill, Joe, John, and Tad. The family attended Holy Family parish. Both Bill and John were pharmacists who graduated from the Cincinnati Pharmacy College. In 1942, Bill bought Dan Collins's pharmacy and operated it as his own until retiring in 1973. His brother John was also a pharmacist and owned the John Dugan Pharmacy at 3707 St. Lawrence Avenue.

Bill's first job was to set up the pins at Holy Family Gym's bowling alley, for which he was paid 2.5¢ per line. In the eighth grade, Bill was hired as a delivery boy by Dan Collins, who owned a pharmacy at Warsaw and Hawthorne Avenues. Here Bill grew more interested in pharmacy, and he later bought the store from Dan Collins, changing the name to the Bill Dugan Pharmacy.

John P. Stryker poses for this picture in 1945. It is believed that the first member of the Stryker family to settle in Price Hill was John Stroeker, born in Baden, Germany, in 1816. He immigrated to Price Hill and married Walburg Smeltz in 1842; she was also born in Baden, Germany (in 1822). In 1876, John Stroeker set a record when he stood on the Ohio side of the river and shot a turkey standing in Ludlow, Kentucky. He was nicknamed the Grizzly of Price Hill. He was also well known for owning the largest orchard within city limits. His brother Peter was a member of the Ohio legislature. John and Walburg had three children: John P., pictured here, a well-known architect; Mary Rist; and Elizabeth Wehner. John P. changed the spelling of the family's name to Stryker. John P.'s son Roger and grandson Andy were very active in the Price Hill community until their deaths. Roger died in 1997, and Andy died in 2004.

David Mann, Cincinnati mayor from 1980 to 1982, plants a tree at an Arbor Day celebration hosted outside the Price Hill public library. Arbor Day was made possible with the help of Price Hill resident John B. Peaslee. Peaslee organized schoolchildren to plant trees around Cincinnati during the American Forestry Congress meeting in 1882. The Ohio governor later declared April 27, 1882, as the first Arbor Day. (Courtesy of the collection of the Public Library of Cincinnati and Hamilton County.)

Margaret Miller sits happily on the front porch of her house at 1137 Gilsey Avenue in 1996. Miller attended Elder High School for one year before the parochial school became all-male. She later married Carl Miller and had six children: Carl, Elizabeth "Betty," Paul, Carolyn, Joe, and Allen. Margaret and Carl often spent Sundays socializing with neighbors on their front porch, as did many Price Hill residents.

Five

NEIGHBORHOOD SITES

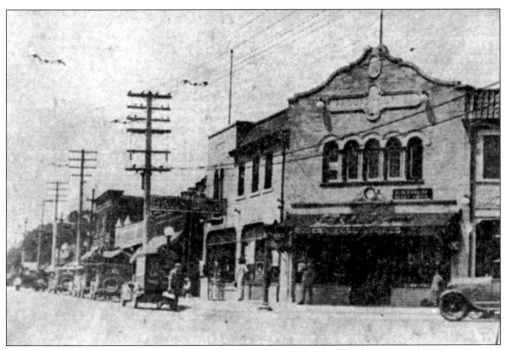

Prout's Corner is where Glenway Avenue, Guerley Avenue, and Cleves Warsaw Pike meet. In 1928, John Prout hired Charles W. Hotchkiss and his son Walter R. "Bud" Hotchkiss to build a large commercial building on this corner. When it was completed, however, Prout did not have the money to pay them. Instead he offered the building to them, but Charles declined, trusting Prout to get the money to pay them eventually.

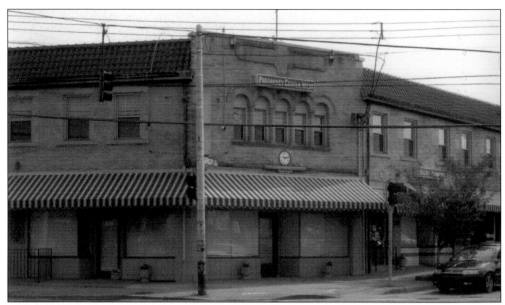

Unfortunately, the stock market crashed a year later, and John Prout sold the building to a different investor and moved to Florida. This, plus the lack of new business, forced the Hotchkisses to close their construction business. Bud worked at a soda pop stand and then at a brewery, and in 1934, he opened the Ideal Café. In later years, the Price Hill Civic Club met at the Prout building until 1994, and in 2008, the building still stands.

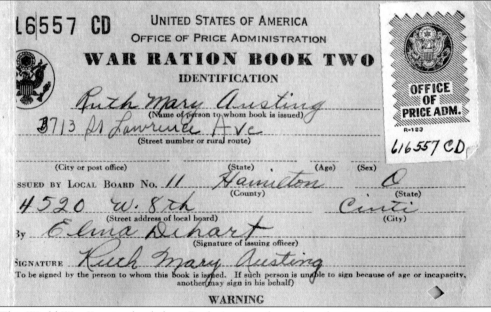

This World War II ration book from Ruth Austing shows that the Price Hill War Ration Board was located at 4520 West Eighth Street. In 2008, this building is now the Blue Note café. Ruth and her sister, Virginia, were lifelong residents of Price Hill; they lived on St. Lawrence Avenue before moving to Century Lane. Virginia worked at the Western and Southern Life Insurance company, and Ruth worked at the Price Hill Eagle Savings and Loan. They were both world travelers as well.

These grounds were originally a farm but became the Branch Hospital for Communicable Diseases in 1879. Then in 1897, the hospital began to treat mostly tuberculosis patients, and it became one of the first municipally owned hospitals to do so. From 1912 to 1927, the hospital was known as the Cincinnati Tubercular Hospital and was later called the Hamilton County Tuberculosis Sanatorium. Dr. Henry Kennan Dunham was the medical director of the hospital from 1909 to 1940, and he was one of the leading researchers of the disease. The hospital was named after him in 1945. Many of the doctors and nurses lived in several buildings on the hospital grounds, including a nurses' quarters with beautiful woodwork and Rookwood tile decoration that served as a recreational building for many years after the hospital closed; the nurses' building was later razed. By 1960, tuberculosis was more treatable, and the hospital started accepting nontuberculosis patients. It closed in 1971, and the property became the Dunham Recreation Center. One building was used as a shelter for neglected children until the mid-1990s; that building later became the community building for the recreation center and is still used for that purpose in 2008.

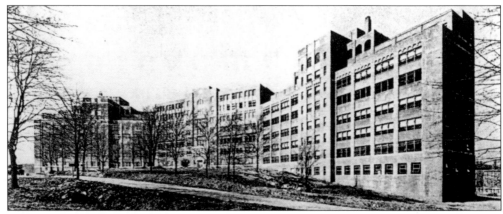

After this hospital closed on June 30, 1971, the Cincinnati City Council donated 80 acres of the site to the recreation commission to create the Dunham Recreation Center and Golf Course (again named after the doctor). Only three original buildings remain in 2008: the Allen House, the old powerhouse and garage, and the occupational therapy building, which is used by the Sunset Players to perform community theater.

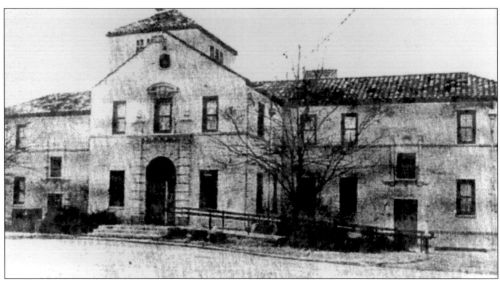

Built around 1914, this building was first used as doctors' quarters and later became the Children's Preventorium of Dunham Hospital. In 1992, the Allen House changed into a day program for children, and it closed in 1995. The Cincinnati Recreation Commission bought the building so that the Dunham Recreation Center could expand.

Overlook Avenue, shown here, was built around 1912. The John Ruebel Construction Company was hired to build the road, and William Koenig, the superintendent of the project, is at the wheel of the steamroller. The road was named for its beautiful views of Price Hill, and an observation platform with an altitude of 942 feet above sea level was raised for those who wanted an even better view.

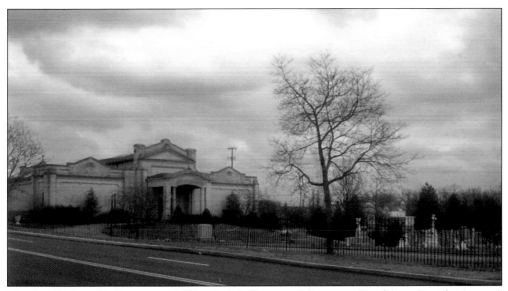

The first St. Joseph's Cemetery on West Eighth Street and Cemetery Road (now Enright Avenue) was consecrated in 1843 and served primarily German families. The mausoleum shown here stands at the new St. Joseph's Cemetery. In 1853, this new cemetery opened two miles west, also on West Eighth Street, to serve English-speaking families. This cemetery is bordered by Rapid Run Road, Nebraska Avenue, West Eighth Street, and Pedretti Avenue.

North of Rapid Run Park, on the left side of Sunset Avenue, are the Judah Touro, Schachnus, and Montifore Cemeteries. There were at one time nine different Jewish cemeteries that represented nine different congregations: Love Brothers, Sephardic, United Jewish, Adath Israel, Montifore Mutual Aid Society, Schachnus, Judah Touro, Hirsh Hoffert, and Chesed Chel Emmes. In 2008, these cemeteries still exist.

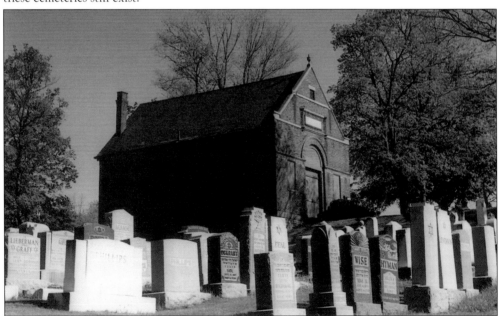

On the other side of the park is the United Jewish Cemetery. This cemetery served Spanish, Russian, and Polish Jews, plus the Love Brothers and Taka Bethe congregations. There were an additional 11 cemeteries in neighboring Covedale: Kneseth Israel; Yad Horitzim; New Hope; Norwood Congregation; Agudas Israel Nos. 1, 2, and 3; Price Hill Congregation; American Beneficial Society; Beth H. Hagodol; and Tiferath Israel.

The Union Baptist Cemetery on Cleves Warsaw Pike was built in 1864 by the Union Baptist Church from downtown Cincinnati. This makes it one of the oldest African American burial grounds in Hamilton County. Tombstones display the names of war veterans, ministers, and other local residents who lived in Price Hill or surrounding areas. In 2008, the cemetery is still used for burials.

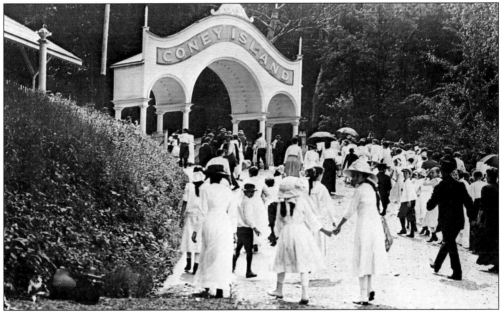

Locals disembark the *Island Queen* riverboat for the annual Price Hill Day at Coney Island, the first of which was held in 1916. Before Price Hill Day, neighborhood businesses sponsored a parade to publicize the event. After a few years' hiatus at Kings Island after Coney Island closed, and then at Stricker's Grove, the neighborhood celebration moved back to the reopened Coney Island in 2000 and has been held there every July since.

Mamie Knight Faulkner (left) is presented with an award on September 7, 1994, to celebrate her home at 716 Mount Hope Road. Due to its historical significance, the Moore-Knight home was placed on the city's historical register on August 3, 1994. Robert Moore built this house in 1859. He had married Anna E. Price, daughter of James and Mary Horton Price, on May 1, 1843, and James donated the land. Mamie moved to this house in 1926 with her parents, her sister Laura, and her twin brother, James. Mamie Knight Faulkner stands with Deborah Horning from the Price Hill Historical Society at the celebration. Mamie worked as a teacher and social worker and, after retirement, volunteered on the Salvation Army and YWCA boards. Her favorite memory of the house was looking out her bedroom window to the streets and river below. Mamie was 89 when she died on July 4, 1999. Horning was very instrumental in getting the Moore-Knight house on the city's register of historic places.

Six

ENTERTAINMENT

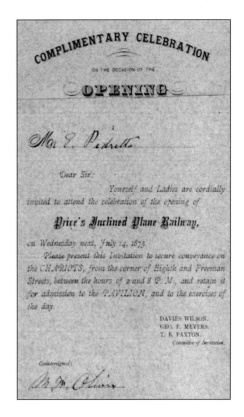

The Price Hill Incline opened on July 14, 1875, as seen by this invitation. The Price Hill House stood at the top of the hill to welcome visitors. The small restaurant served nonalcoholic drinks (a rule passed down from William Price) and had gorgeous gardens and views of the surrounding towns. Once at the top of the hill, citizens could ride a horsecar line from the top of the incline to the city limits.

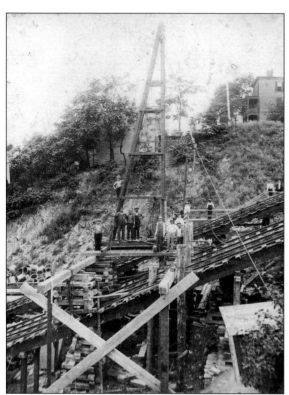

William Price, son of Rees, helped build the incline. He bought the land from Peter Filsner, whose son Charles worked on the incline for 48 years. The double-track incline spanned 80 feet of land and took passengers up 350 feet from bottom to top, ending at West Eighth Street and Matson Avenue. One side of the incline carried passengers in two cars, and in 1876, a freight side was opened. From 1889 to 1893, it is estimated that more than a million people rode the incline.

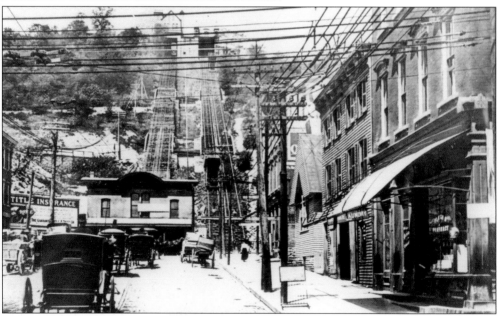

In 1890, new cars and a new engine were added to the freight side of the incline, and in 1891, the track and bridges were repaired. In 1928, electricity replaced the steam machines, shortly before the freight side of the incline shut down due to lack of use. There were two accidents while the incline was open, but no one was ever killed. The second accident occurred on July 31, 1943, when a car jumped the track. The incline closed later that year.

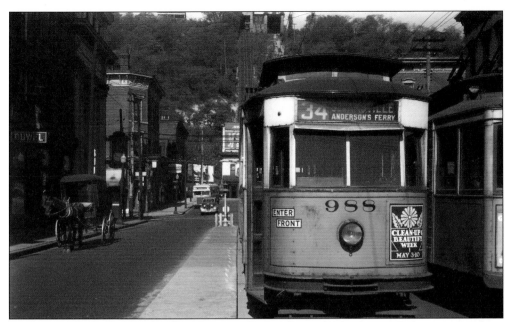

On May 11, 1937, the Price Hill Incline stands proudly in the background. At one time there were five inclines: Mount Auburn, Price Hill, Bellevue, Mount Adams, and Fairview. There were grand restaurants at the tops of the Mount Auburn, Price Hill, Bellevue, and Mount Adams Inclines. All five inclines stimulated growth in these hilly neighborhoods, but in 2008, they are all closed.

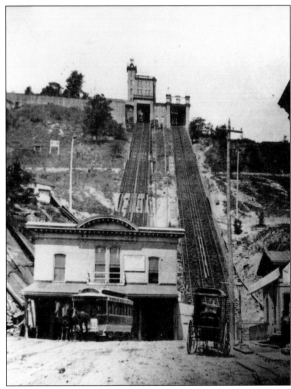

Legend says there were three saloons at the bottom of the incline, each with its own saying: "First Chance," "Next Chance," and "Last Chance." After a dry 10 years, alcohol was served in the Price Hill House. A fire ravaged the restaurant in December 1899, but it was reopened by 1901. The Price Hill House closed in 1938, just a few years before the incline shut down. Around 1948, it was torn down to make way for the WSAI radio transmitter.

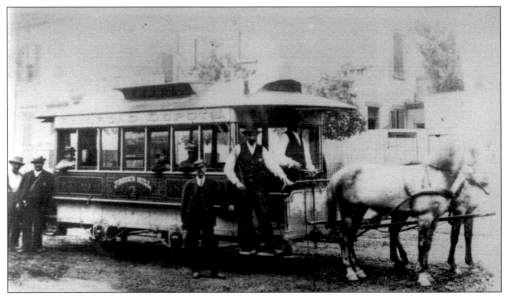

The Price's Hill horsecar, shown here in the late 1880s, traveled along West Eighth Street and down Warsaw Avenue to deliver people and goods throughout Price Hill. It was the job of the "hill boy," so called because of the worker's young age, to hitch extra horses to the cars on steep hills. These horsecars were later replaced by the Warsaw streetcar, which ran to Glenway and First Avenues.

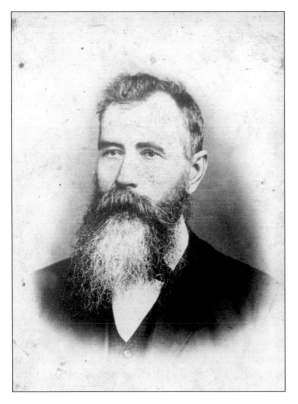

John Klosterman, shown in this picture, lived in a house that he built in 1838. In 1908, Klosterman sold most of his property to the City of Cincinnati for the proposed Mount Echo Park. The park was named for the sheer cliffs and the echoes they produced. The entrance wall, outside Mount Echo, was built in 1913. During the spring of 1988, volunteers rehabbed the stone structure at the front entrance of Mount Echo Park.

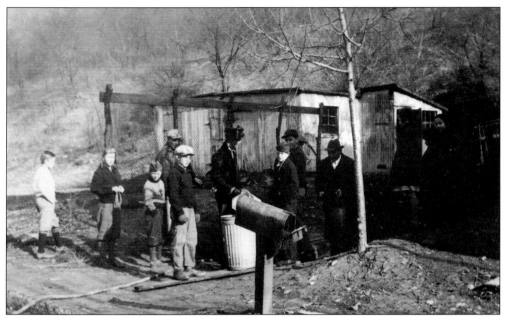

This picture was taken at Mount Echo Park by Leonard Schumann in 1937, during Cincinnati's great flood. Since the park was on such high ground, residents drew clean water from the water supply in the park. Construction of the pavilion in Mount Echo Park was completed in 1929. In 2008, the park still stands at 381 Elberon Avenue and includes an overlook, pavilion, secondary picnic shelter, and children's play equipment.

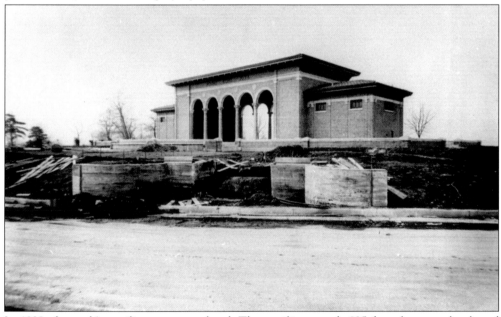

In 1929, the park's pavilion was completed. The pavilion stands 825 feet above sea level, and it has been used for concerts, plays, picnics, weddings, fairs, and many other public activities over the years. Below the pavilion is the overlook, with its magnificent view of Kentucky and the S bend in the Ohio River. Because the hillside was slipping, the overlook was completely remodeled in 1986.

A community picnic at Mount Echo Park around 1915 shows many kids playing on the swing set that continues to be used in 2008. Behind these swings is a second stone picnic shelter built by the federal Works Progress Administration between 1931 and 1938. During this time, the park was a popular place for big band dances and many other celebrations.

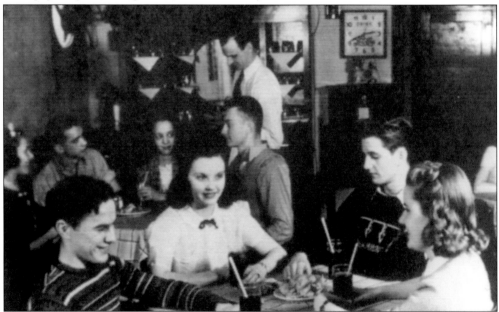

Peggy's Grill was a popular hangout for area high school students, especially those who attended Western Hills High School. The grill stood on Glenway Avenue near West High Avenue and served up classic American dishes for lunch and dinner. The restaurant was known for its double-deckers, steak sandwiches, and rathskeller. It opened around 1933 but closed sometime between 1945 and 1954.

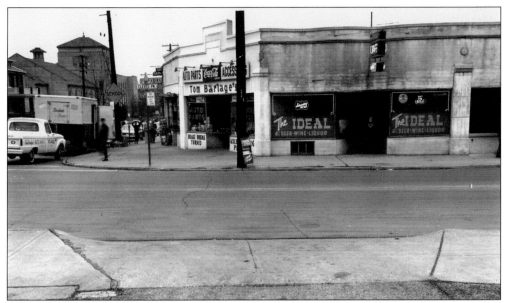

Bud Hotchkiss owned the Ideal Café at 4905 Cleves Warsaw Pike. Bud owned the café from 1934 to 1974 and tended bar for several years after that. Bud (November 22, 1906–November 4, 1993) married Alice McGinley and raised two sons, Walter "Roy" Hotchkiss and Charles Dennison Hotchkiss. He also wrote a memoir called *Nobody Works*. In 2008, the bar is named Old Time Saloon and still operates in the same location.

Members of the Avilians community theater group in 1974 include, from left to right, (first row) Julie Hotchkiss, Amy Hotchkiss, Mark Elsener, unidentified, Peggy Westrich, and Russ Maue; (second row) Valerie Hotchkiss, Cindy Thomas, Bob Adams, John Procaccino, and Charlie Hotchkiss. The Avilians performed at the auditorium on the third floor of St. Michael's school building, near West Eighth Street and State Avenue. The auditorium and stage were built originally for German opera.

The Holy Family players guild was another community theater group during the 1950s and 1960s. Directed by LaVonne Moloney, it hosted musical variety shows. This photograph is from the 1951 show "Come to the Mardi Gras," and the performers include Chuck and Jim Bell, Ernie Beverman, Les Boile, Holt Brady, Larry Brogan, Myrtle Chessey, John DiMuzio, Ron Eby, Gladys Gaupel, Joe Gramann, Ceil Greivenkamp, Mary Clare Heimbrock, Bea and Larry Lampe, Maureen McGrail, Mildred Mentrup, Lois Moloney, Marilyn Niemeyer, Larry Niemeyer, Wilson Rohan, Mary Rohe, Vito Rossi (playing the accordion), George and Gene Sunderhaus, and Marge Timmons. Other parishioners who participated were Dollye Moloney, Joan DeWald, Carolyn Black, Ann Dirr, Ann Bockenstette, Anna Marie Peters, Ken and Carolyn Eby, Carol Bohrer, Martha Sunderhaus, Mike Berda, Mary Ann Reese, Bob Steiger, Bill Herbst, Pete Geis, Helen Costa, Marge Holscher, Agnes Hermes, Mildred Rottenberger, Carolyn Coate, Bernette O'Brien, Roger Smith, Janice Sinnard, Bob Knapke, Audell Kunk, Flo Kleiner, Bud Rafferty, Lee Schneider, Marge Wagner, Linda Sweeney, Tom Faeth, and many others.

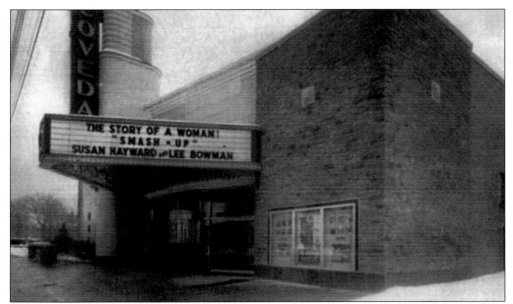

The Covedale Theatre was the last theater to open (on April 6, 1947) in Price Hill, at 4990 Glenway Avenue near Ferguson Road. It was converted to a duplex cinema in the late 1980s, and in 1997, the Cinema Grill Company began operations there and served food during movies. A local theatrical production company, Landmark Productions, headed by Price Hill native Tim Perrino, bought the theater building in 2001 and turned it into a venue for live theater.

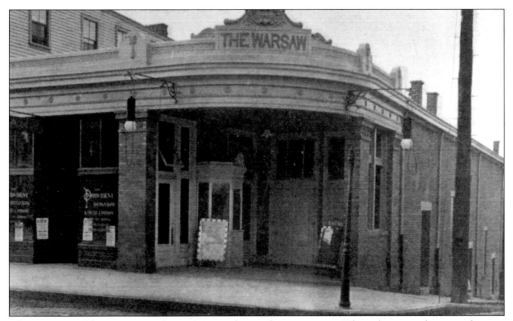

The Warsaw Theatre opened in 1911 to show silent pictures. This photograph was taken in 1912. The first theater in Price Hill was the National Theatre, also called the Depot, which opened near West Eighth Street and State Avenue. Later the Overlook Theatre opened in the early 1930s on Cleves Warsaw Pike at Rulison Avenue, and in 1946, the Sunset Theatre opened at Glenway and Sunset Avenues. All Price Hill movie theaters are now closed.

Minstrel actors pose for a photograph inside the Western Plaza Theatre. This show was hosted by the Price Hill Business Club on February 5 and 6, 1917. Such minstrel shows were popular before the American Revolution and increased in popularity after the War of 1812 before dying out by the 1950s due to objections about white men and women pretending to be African American. This popular moving pictures theater closed in 1965.

This photograph taken in 1921 is of the Crow's Nest tavern, which started as the John Crowe's Roadhouse in 1895. The bar sits at the end of West Eighth Street, which was once the end of the line for the Elberon Avenue streetcar line. Maureen Bonfield owned the restaurant from about 1958 to 1972. In 2008, the bar is simply called the Crow's Nest, and the current owner, Glenn O'Dell, is related to the original founders.

Madie Paddack prepares to make a putt on hole 13 at the Western Hills Country Club in 1913. This club was originally named the Elberon Country Club and was located at Overlook Avenue and Rapid Run Road in Price Hill. But its name changed to the Western Hills Country Club in 1912, and around 1913, the club moved farther west to entice more residents to join.

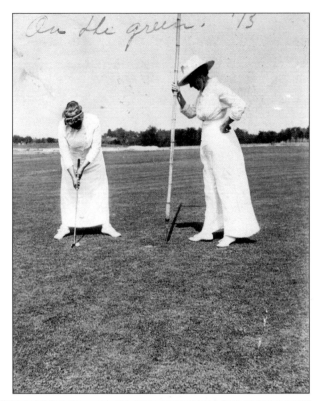

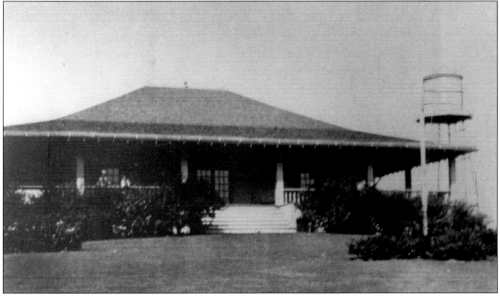

After the club's move, this former club building was remodeled into the Elberon Presbyterian Church. Later Hiram M. Rulison bought the country club land on Overlook Avenue and developed the 45 acres into the Glenway-Elberon Heights Subdivision, although this building still stands in 2008 as the Liberty Missionary Baptist Church. In 2008, the Western Hills Country Club remains in operation at the location it moved to in 1913, at 5780 Cleves Warsaw Pike in Western Hills.

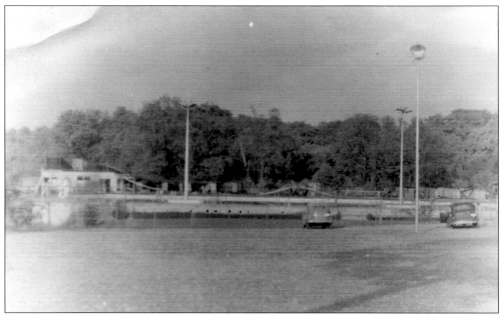

After a fire on June 29, 1937, the Philipps Swim Club suffered major damage. Louise Philipps originally owned the club, and her children, Frank Jr. and Miriam, took over until their deaths in 1966 and 1970, respectively. Don Schmidt owned the pool until 1999 and then sold it to the Childers/Driehaus family. In 2008, the Price Hill Philipps Swim Club is still open at 1536 Sidona Lane, just off Glenway Avenue.

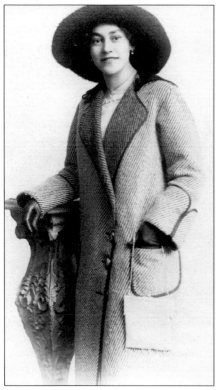

In 1919, Lorain Geissler Ruehlmann won the award for Best Dressed Woman on Price Hill. At this time, she lived at 403 Purcell Avenue and was the mother of Richard Ruehlmann. Louise was an aunt to Elmer and Eugene Ruehlmann—twin boys who also lived in Price Hill. Eugene went on to serve as mayor of Cincinnati from 1967 to 1971.

The Blue Note building, at 4520 West Eighth Street, was built in 1911. In the 1940s, Norma Berryman and her mother turned it into a hip jazz club. It was called the Blue Note (originally), the Blue Note Café (1954), Tee's Blue Note (1970), and the JC Lounge (1985). In 1989, Doug Gundrum started rehabbing the building, and in 1990, it opened once again as the Blue Note, hosting rock and other contemporary musicians.

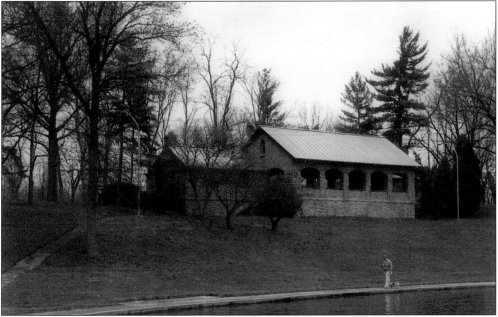

Rapid Run Park sits on a large plot of land at 4450–4548 Rapid Run Road. One side of the park features a large walkway around this shelter house, built around 1939 along with a small artificial lake. When this park was built, from 1928 to 1930, it was originally named Lick Run Park. The park was renamed Rapid Run Park in 1942.

Glenway Woods, shown from Fairbanks Avenue on October 11, 2000, is still a nature preserve in 2008. The 30-acre preserve boasts an 150-foot elevation change and plenty of photographic opportunities. Prior to being a nature preserve, much of the land was owned by private property owners or the Cincinnati Public Schools. Soon the hard-to-develop land was made into Glenway Woods, and in 1974, there was a push to expand. In 1977, the preserve was officially created.

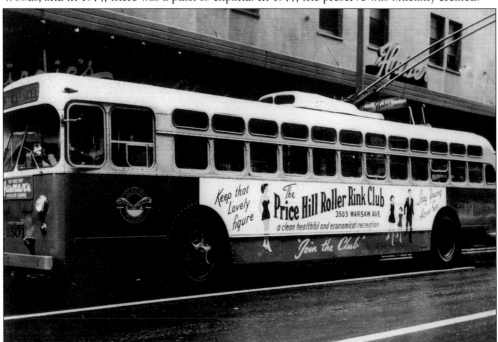

Charles Meyer opened the rink at 3500 Warsaw Avenue in 1949 with Cap Sefferino as manager (Sefferino worked at the rink until his death in 1967). Popularity for the rink soared in the 1950s and 1960s, but by the late 1960s attendance declined.

Eileen Bagot was just 17 when she was crowned the Roller Skating Queen of Ohio in 1966. Bagot lived on First Avenue and was a senior at Seton High School at the time. She partnered with David Vowell to place third in the novice dance class in Toldeo. Other Price Hill participants who took home awards were Kim Roche, Kevin Roche, and Gail Martin.

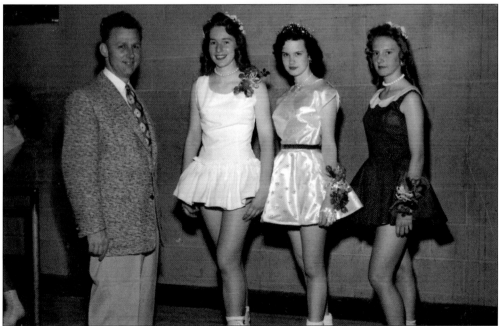

This photograph was taken in 1956 at the Price Hill roller-skating rink. From left to right stand Charles Meyer, Kathy Maley (Queen of the Rink in 1956), Patty Bowman, and Sue Lustenberg. In 1988, Meyer donated the building to St. John Social Services, which used the building for two years before selling it to the Salvation Army.

DISCOVER THOUSANDS OF LOCAL HISTORY BOOKS
FEATURING MILLIONS OF VINTAGE IMAGES

Arcadia Publishing, the leading local history publisher in the United States, is committed to making history accessible and meaningful through publishing books that celebrate and preserve the heritage of America's people and places.

Find more books like this at
www.arcadiapublishing.com

Search for your hometown history, your old stomping grounds, and even your favorite sports team.

Consistent with our mission to preserve history on a local level, this book was printed in South Carolina on American-made paper and manufactured entirely in the United States. Products carrying the accredited Forest Stewardship Council (FSC) label are printed on 100 percent FSC-certified paper.

MADE IN THE